100

WAYS TO TAKE BETTER

BLACK AND WHITE
PHOTOGRAPHS

MICHAEL MILTON

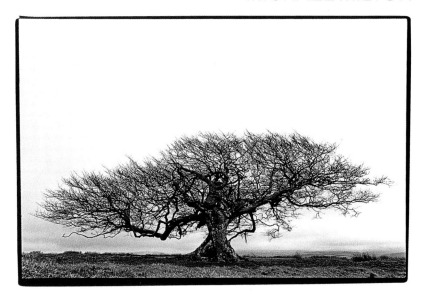

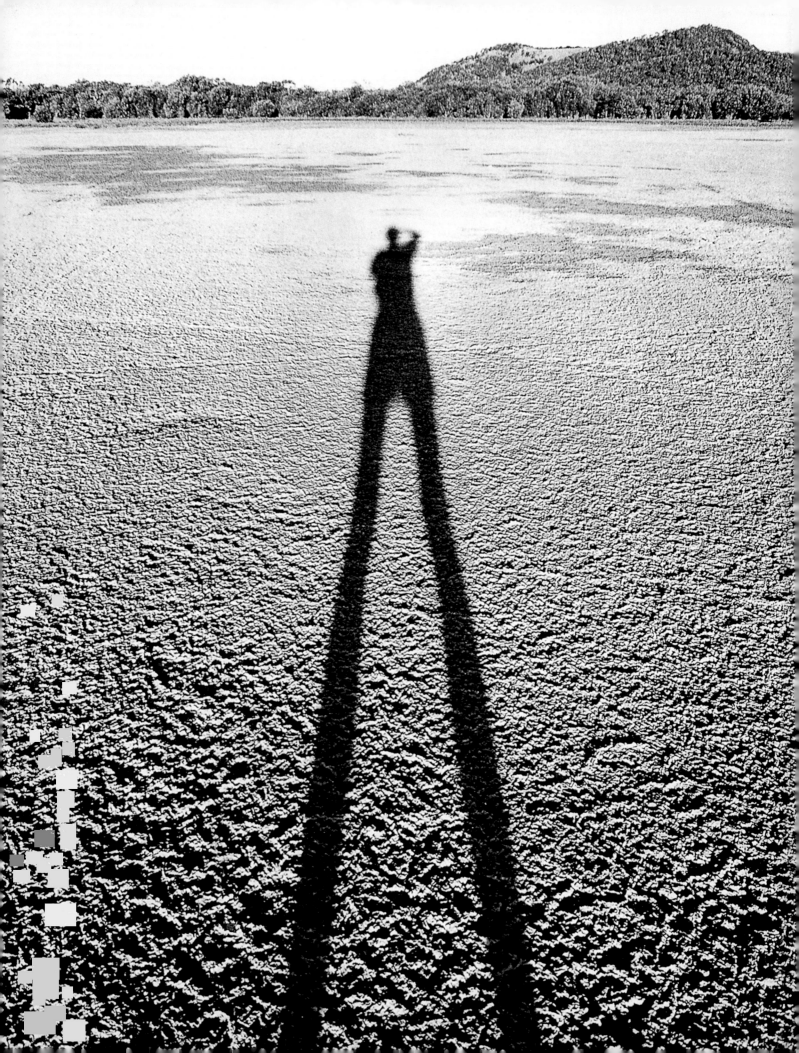

100
WAYS TO TAKE BETTER
BLACK AND WHITE PHOTOGRAPHS

MICHAEL MILTON

D&C
David and Charles

A DAVID & CHARLES BOOK
David & Charles is a subsidiary of F+W (UK) Ltd.,
an F+W Publications Inc. company

First published in the UK in 2005

Copyright © Michael Milton 2005

Distributed in North America
by F+W Publications, Inc.
4700 East Galbraith Road
Cincinnati, OH 45236
1-800-289-0963

A catalogue record for this book is available from the British Library.

ISBN 0 7153 2034 3 hardback
ISBN 0 7153 2035 1 paperback

Printed in China by SNP Leefung
for David & Charles
Brunel House Newton Abbot Devon

Commissioning Editor Neil Baber
Desk Editor Lewis Birchon
Art Editor Mike Moule
Designer Sarah Clark
Production Controller Kelly Smith

Visit our website at www.davidandcharles.co.uk

David & Charles books are available from all good bookshops; alterna-
tively you can contact our Orderline on (0)1626 334555 or write to us at
FREEPOST EX2 110, David & Charles Direct, Newton Abbot, TQ12 4ZZ
(no stamp required UK mainland).

Contents

Introduction

Despite the fact that colour photography has been possible for over 100 years, there is something about the medium of black-and-white that has made it the pre-eminent means of expression for photographic artists from Ansel Adams to Henri Cartier-Bresson. It is under renewed attack now that digital photography has taken such a hold, but I suspect that it will resist this revolution as it has resisted others before and that monochrome photography will continue to be the fascinating and compelling visual art form that it has always been and photographers will continue to be seduced by its qualities.

Why the black-and-white image should have such power is hard to say but without the distraction of colour there must be more emphasis placed on line, form, light, shade and tone. A black-and-white photograph can never pretend to be a 'true' representation of a subject – perhaps a colour one cannot either – but the act of turning a subject into an arrangement of tones without colour is an act of transformation and the photographer must decide how the subject is to be translated into the language of light and shade.

Without the distraction of colour there must be more emphasis placed on line, form, light, shade and tone

This creativity is, for me, the principal pleasure of photography; technical issues are secondary to creative ones and my methods attest to this. My own style is to keep everything as simple as possible; you will not find in these pages reference to complicated and expensive equipment, nor do I believe you need to have an encyclopedic knowledge of the zone system to calculate your exposures. I predominantly use a 35mm SLR camera, a limited selection of lenses, almost never use flash and make simple calculations based on TTL (through-the-lens) spot-meter readings to decide on camera settings. I have assumed that this is more or less the kit that the reader will use. You will not need more and in fact much can be achieved with less. My basic method, as you will see throughout the book, is to take a spot meter-reading from various areas of a scene establishing the extremities of brightness and shadow and usually a mid tone as well, and then calculate my exposure based on that.

The book is broken into chapters dealing at first with basic technique, and then with different subject genres from landscapes and still lifes to architecture and portrait photography. As well as some technical tips, there are many ideas for where to go and what to take photographs of. Although some tips will work better for the black-and-white photographer, there are many ideas

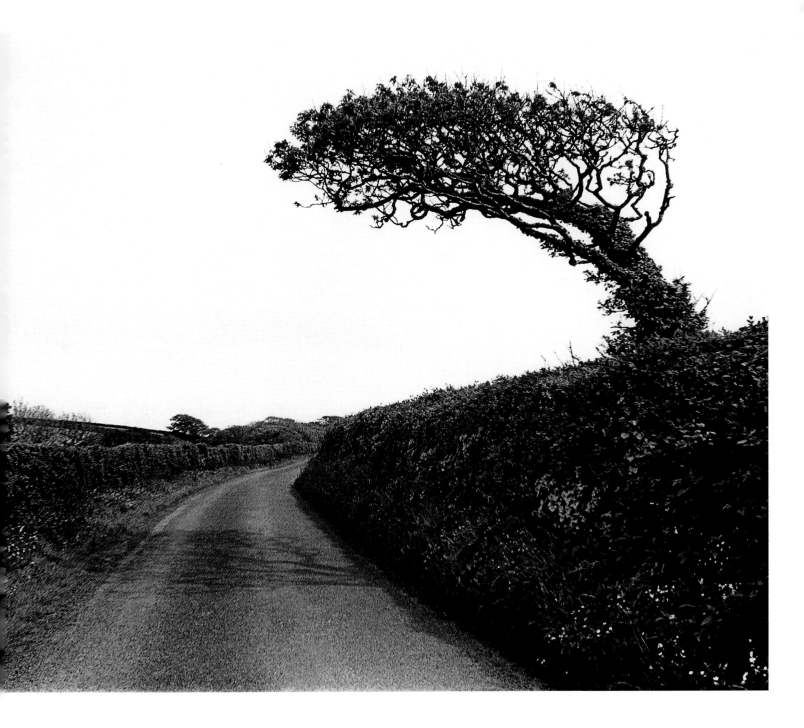

and principles that will apply equally well to colour photography. Likewise to digital photography – it's easy enough to convert a colour digital image to monochrome but it will always be more successful if you have been 'thinking in black-and-white' when taking the photograph.

This book is not intended to be an encyclopedic technical study of everything that is possible with black-and-white photography or a definitive guide to how it is done, but rather 100 tips and suggestions, either on how to take a better picture or on where to look for one, based on my own taste and experience. I have developed my own style and technique through many hours of practising my art, and I hope this book will give you plenty of inspiration to go out and do the same.

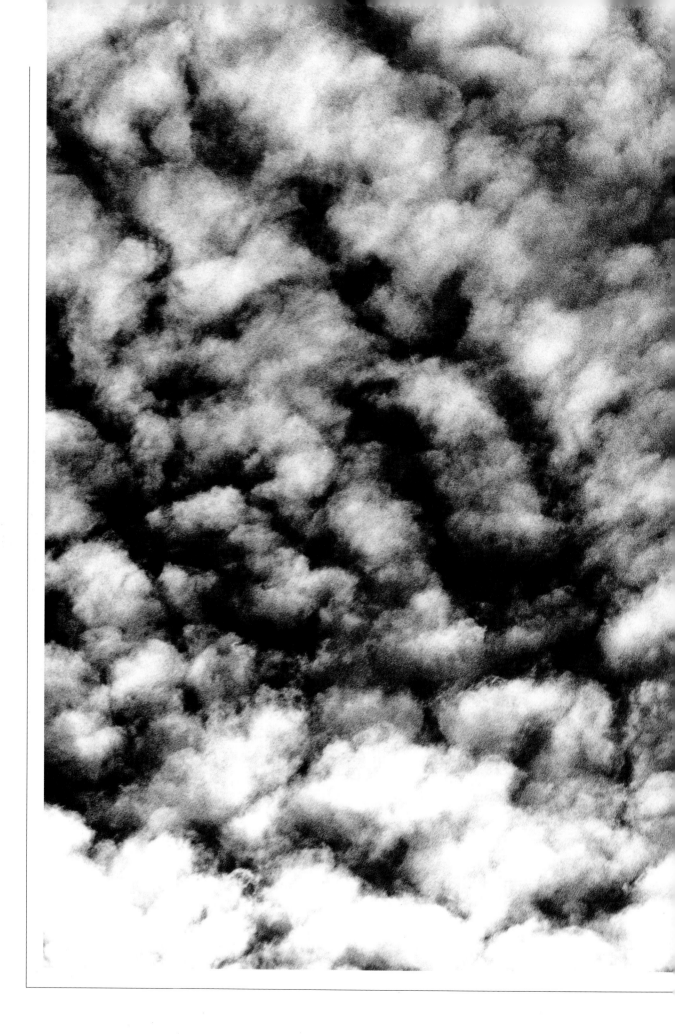

Camera Technique

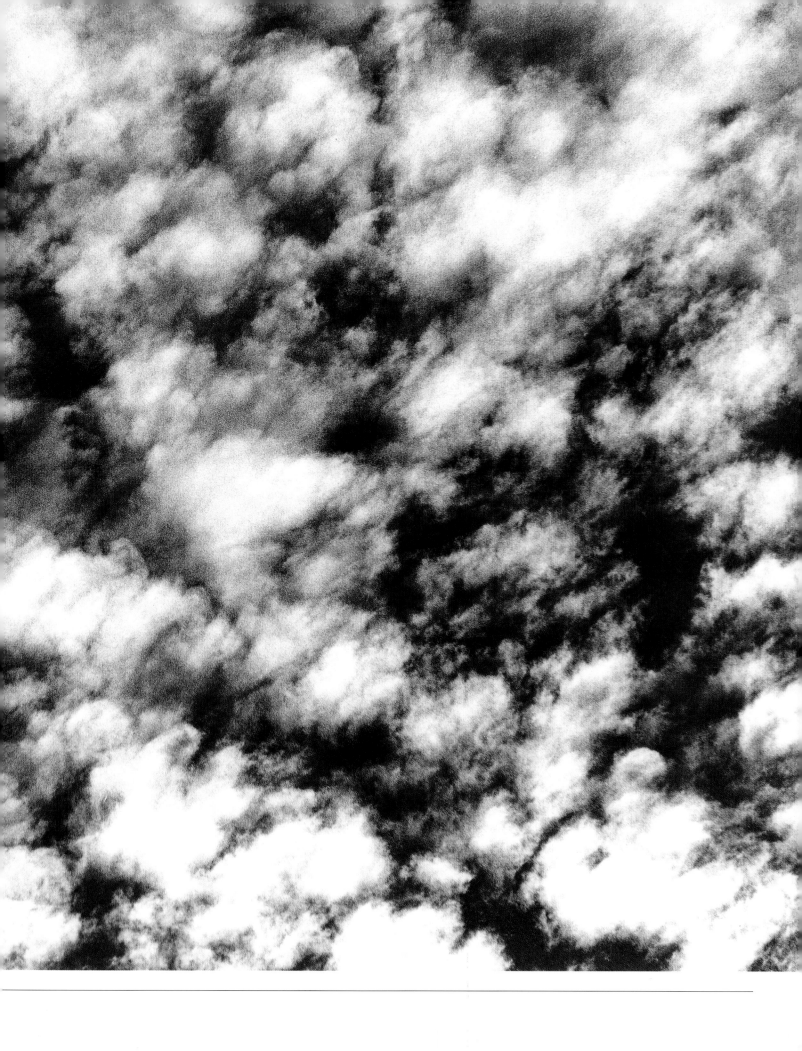

1 Think in black-and-white

The great advantage of black-and-white photography is that it frees us from the shackles of straight representation. We are much less distracted by notions of what things are supposed to look like and more emphasis is thrown on to the photograph and how you have chosen to represent your subject. There is limitless opportunity for creativity but you must learn to think in black-and-white; translate what you see into the language of light, tone, shape and form. How will colours record as tones? What are the dominant shapes and lines in a composition? How can you manipulate the tonality to suit your own ends? Above all watch the play of light, shadow, reflection and highlight. Start to think of a photograph as a graphic composition comprising these elements.

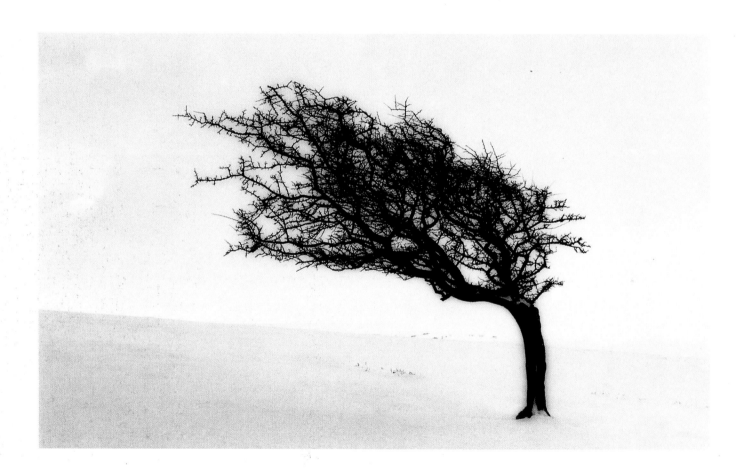

Windswept tree in snow

This windswept tree after snowfall on Exmoor, in the UK is an ideal example of what black-and-white photography is all about. The sky and land were a white-out and all other objects looked black in this environment. Because the foreground and sky are of similar tonality, the tree stands out starkly, but the foreground snow was in fact slightly darker than the distant background which gives it a little tone and helps give the image a sense of solidity and perspective. I took an average meter reading and opened the lens up one stop to ensure the snow recorded white and not a muddy grey.

35mm SLR camera, 28mm lens, yellow filter

2 Keep it sharp

Modern photographic lenses are of tremendous quality and can produce pin-sharp images. To achieve a really crisp result and avoid camera shake it's best to use a tripod but it's not always possible to have one with you, so learn how to hold your camera still and to release the shutter smoothly to avoid any camera movement. If you have to lean over or adopt an unstable position to get the shot, brace yourself against a solid support such as a tree or fence and try to calm yourself by breathing slowly and deeply. A shutter speed of around 1/125 sec can easily be hand-held with a standard or wide-angle lens but when longer focal length lenses are used it will need to be faster. The rule of thumb is the sizes of lens should be similar to the shutter speed, for example a 200mm lens would be used at a minimum of 250 sec when hand-holding.

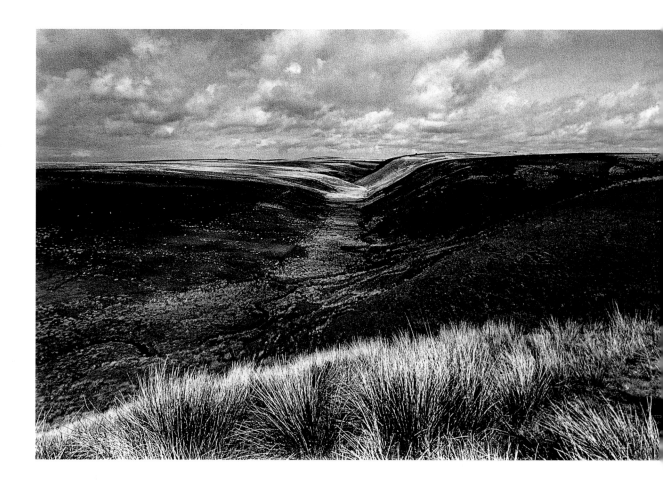

Valley

This valley is on the Somerset side of Exmoor and I had photographed it before a number of times. I was passing by in the late afternoon on a spring day and found the air particularly clear and sharp with clouds sweeping across the sky creating areas of dappled light constantly moving across the scene. Using a tripod I made a series of exposures at an aperture setting of f/16 to keep depth of field throughout the image.

35mm SLR camera, 28mm lens, green filter

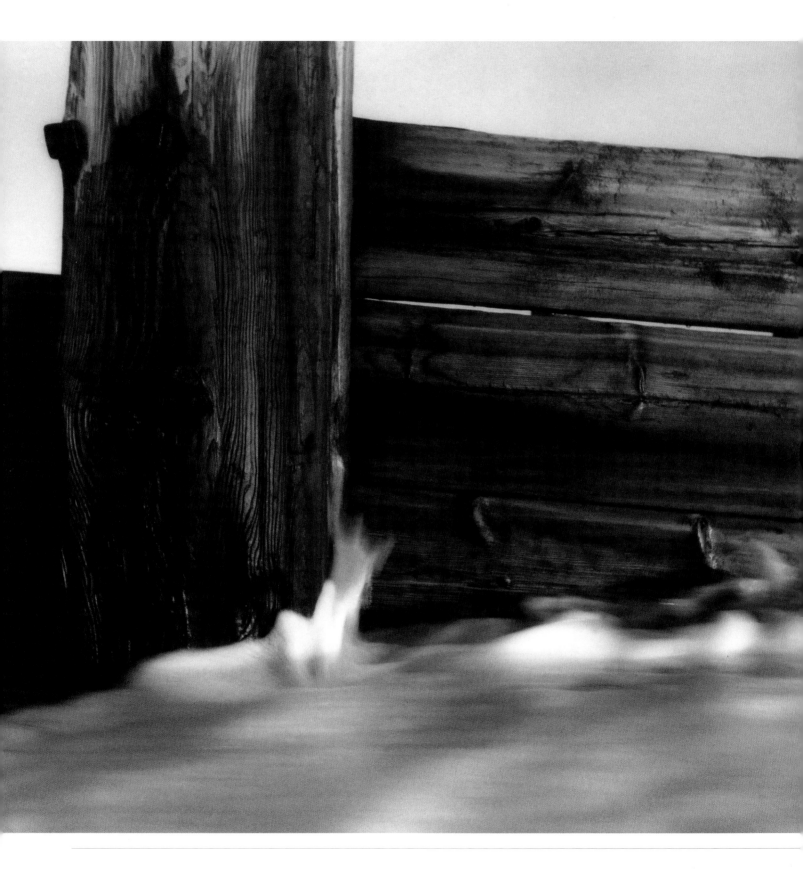

3 Create blur with a slow shutter speed

Deliberate use of a slow shutter speed can introduce a feeling of dynamism and movement into photographs of all subjects. Anything from 1/15th of a second up to several seconds exposure can be used to create different effects. Water is one of the most rewarding subjects to shoot in this way; with the camera on a tripod, waterfalls, streams, rivers or the sea can be made to show a suggestion of movement or, with an exposure of a second or more, transformed into an ethereal mist. The same technique can work on almost any moving subject such as traffic, people or animals. Foliage, grass or swaying crops can work well, giving a feeling of living movement in the landscape, and can be used to create a more consistent backdrop to a static subject in the same way as using a wide aperture to blur the background. You could even try deliberately moving your camera while on a slow shutter speed to create interesting blurring effects and distortions.

Groyne and sea-movement

I photographed this scene on a beach in Devon in the UK, when the tide was high, one late afternoon in winter sunshine. With low light illuminating the groyne and the surf moving around its base, it was an interesting subject to explore. Looking for a viewpoint, I had to go low to frame the image, and given that I had no tripod with me I had to keep still so as to keep the groyne in sharp focus. I used a shutter speed of 1/8 sec in order to give the impression of the water moving in the foreground.

35mm SLR camera, 28mm lens, orange filter

4 Freeze movement with a fast shutter speed

A sufficiently fast shutter speed will freeze movement and capture crisp and sharp images of subjects in motion. The speed necessary varies depending on the subject: very fast-moving subjects such as cars or fast-flowing water may need a speed of 1/1000 sec or more to completely freeze movement, whereas someone walking towards you could be effectively shot without motion blur at as little as 1/125 sec. It is the light available that will restrict the speed you are able to set, so the best advice is to use as fast a shutter speed as the light will allow. A useful bonus of this technique is that camera shake is eliminated and you can hand-hold with confidence. This will liberate you from using a tripod, and means that you can keep on the move along with your subject.

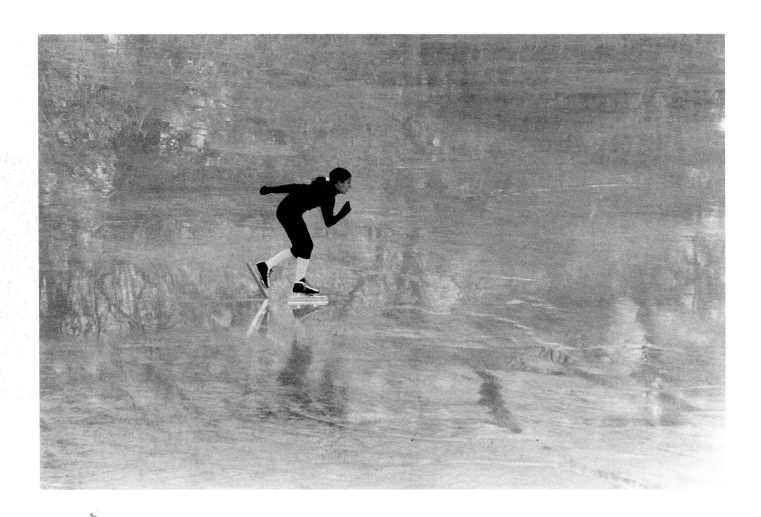

Skater

I loved the reflections on this ice rink in the Hungarian city of Budapest and wanted to capture the skater in sharp silhouette against it. I used a telephoto lens to get closer and fill the frame with the ice, and a shutter speed of 1/500 sec to freeze the motion of the skater. I panned with the skater as she moved and had to continually re-focus as depth of field was limited.

35mm SLR, 200mm lens, green filter

5 Take control of the depth of field

Depth of field is the area within a scene in front of and behind your point of focus that appears in focus in the final image. This can vary from as shallow as a few millimetres to the whole of a wide landscape, dependant on the focal length of the lens, the aperture setting and the focusing distance. Mastery of this technique is one of the fundamental skills of good photography, from deliberately taking the background out of focus to keeping everything from foreground to infinity in focus for a wide sweeping landscape. For maximum depth of field choose the smallest aperture, and focus to about a third of the way into the scene. A wide-angle lens gives greater depth of field than a telephoto, so for total sharpness from corner to corner use a wide-angle lens such as a 28mm with a small aperture setting.

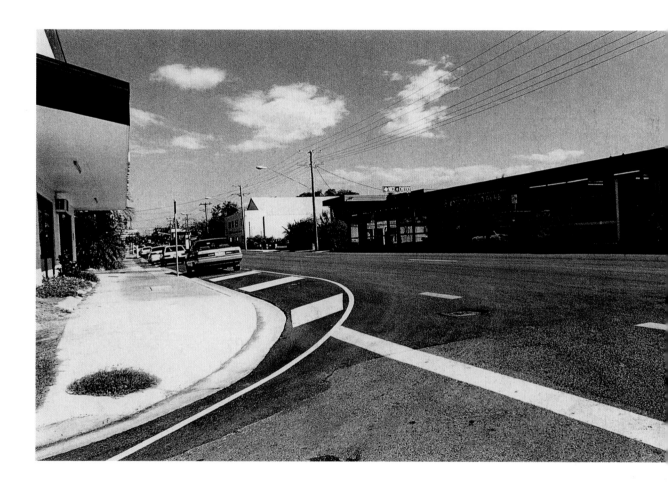

Street scene

For this street scene in a town called Gladstone in Queensland, Australia, I wanted to emphasize the line of the straight road disappearing into the distance. I used the painted white line as a lead-in to the picture and wanted to keep the focus from the road in the immediate foreground to the back of the picture.

Although I set the camera at f/16 I was still able to hand-hold as the bright Australian sunlight was sufficient on its own to give me a reasonably fast shutter speed.

35mm SLR, 28mm lens, yellow filter

Camera Technique

6 Throw the background out of focus

For some photographs you may not always want maximum depth of field, and being able to allow specific parts of the image to fall in and out of focus means you can draw attention to other areas in the picture. The most common use of this technique is to allow a background to blur, leaving the subject standing out in sharp focus. If you use a wide aperture, the depth of field will be minimal and by placing the subject some distance from the background the effect will be accentuated. The longer the lens, the more the blur and distortion, subduing even the most intrusive background.

Model and mountains

Photographing this model in the Carpathian mountains in Slovakia, it was important to include the setting, which contributes greatly to the atmosphere of the image. I wanted the model to appear in harmony with the surroundings but I didn't want the landscape to detract from the main focus of the image. I used a standard lens and set the aperture at f/4. I focused on the model, allowing the background to fall out of focus but still remain an important feature of the photograph.

35mm SLR camera, 50mm lens, green filter

Camera Technique

7 Use the whole frame

If you concentrate on framing your subject by using the aiming device in the centre of the viewfinder, the result is often disappointing with unnecessary and uninteresting space around the central focus. Paying attention to everything within the frame will dramatically improve your photographs. By simply being more aware of everything that surrounds your subject you can compose your picture more carefully, either by eliminating or deliberately placing other elements in the composition, or indeed by actively using the edges of the picture area itself to create dynamic crops and interesting compositions.

Two buildings

Coming across these two buildings with different brick-work in London, I felt the contrast would make a good composition. I angled the camera in several different ways before I decided the darker structure was best placed just inside the top left of the frame, using the graphic line of the lighter building to take your eye into the photo. The darker building has equal visual weight to the lighter building, which is larger, therefore the overall composition is harmonious. The silhouette rectangle balances the weight on the right side of the photograph. Metering from the shadowed area of the lighter building, I made a series of exposures.

35mm SLR camera, 28mm lens, orange filter

18

8 Meter the light and choose your exposure

Your camera's automatic setting may give acceptable results in most situations but it pays to make a more creative decision over your exposure. Black-and-white photography is not about getting the 'correct' exposure, but about choosing the tonality you want to achieve in your final print. To get an accurate reading of the light, take readings from important areas in the scene: the deepest shadow, a point of brightest highlight, and a point that can be taken as a mid-tone. Remembering that the reading you get will render that area as a mid-grey (18 per cent), these extremities will give you the information you need to decide how you want the scene to record; you may want to make sure pale tones record as pure white and so open up a couple of stops, or close down to create a dark and sombre effect with mid-tone highlights and deep shadow areas. I use the built-in TTL (through-the-lens) spot meter in my camera, but if yours doesn't have one, try moving closer in order to meter a specific area of your subject.

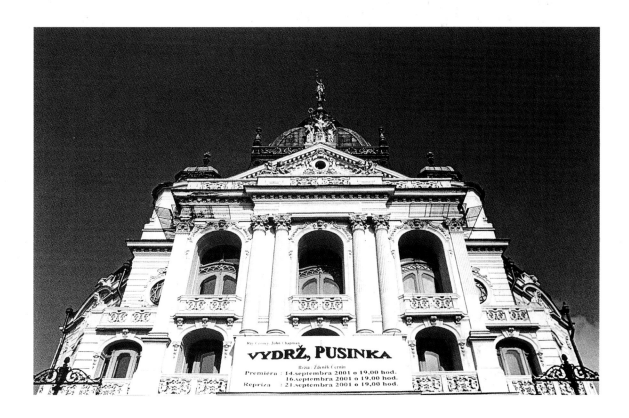

Opera house

I decided to photograph the opera house in Kosice, Slovakia, fully from the front. I wanted a dark sky but also to keep the details of the building, so I took a series of light meter readings: the cobbled stones of the pavement which I decided would be my neutral tone (the equivalent of 18 per cent grey), the front of the opera house, which was brighter, and the sky. Knowing the differences between the metered subjects, I could calculate the shutter speed and aperture and make sure that detail remained in the white frontage of the building. An orange filter helped darken the sky.

35mm SLR camera, 28mm lens, orange filter

Camera Technique

19

9 Use exposure compensation

Although black-and-white photography allows more latitude for exposure 'errors' than colour, in many situations it's still a good idea to bracket exposures to make sure you don't end up with a drastically under- or overexposed, and therefore unusable, image. The useful exposure compensation dial is an effective way of doing this, allowing you to add a little more or a little less exposure than that indicated by the camera's exposure meter. Getting the exposure right when you capture the image will save much time and frustration later down the line in the darkroom or on the computer. Set a '+' value and it will increase exposure, a '–' value and it will reduce the exposure, usually in 1/2 or 1/3 stop increments; the camera will make a series of slightly differing exposures.

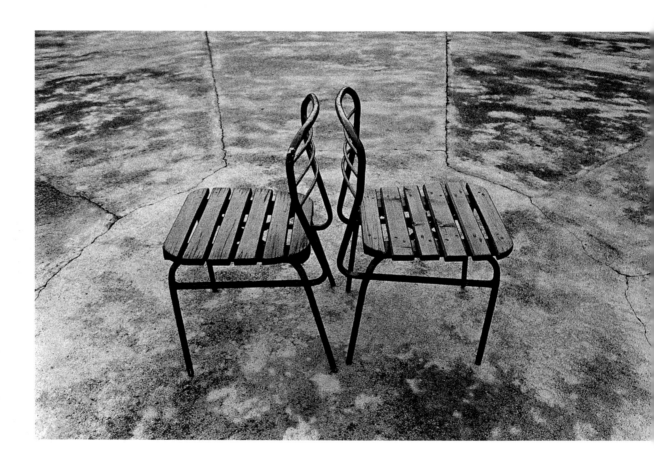

Two chairs

On an overcast day with a white sky and good light I came across these two chairs at a lakeside café in Slovakia. As it was late September and the end of the season, I thought the chairs represented the empty and tranquil nature of the place and would make an interesting photograph. With large areas of even tone and low contrast, it was important to get the exposure right. Metering from the concrete floor and setting the camera, I made three exposures using the same aperture and shutter speed; the first as normal, then I moved the exposure compensation dial plus a third, and then plus two thirds making two more, lighter exposures, which gave me a choice of negatives to print from.

35mm SLR camera, 28mm lens, yellow filter

10 Develop good working habits

Often the best opportunities for a good photograph occur unexpectedly and disappear again without warning. This is as true of landscape photography as it is of reportage, as it may be that the sun will only peek from behind a cloud or cast a particular shadow for a very short time. To make the most of these moments, using your camera should become instinctive – a subconscious method of working that will allow you to concentrate on your subject and not trip up on your equipment. Following a regular working routine will help enormously. Whenever I find something worth photographing I automatically follow the same sequence: a) look for a viewpoint; b) decide what filter to use, if any; c) meter and compose; d) check that the aperture and shutter speed is the best combination; e) consider if the composition can be improved; f) focus; and g) wait for the best moment to press the shutter.

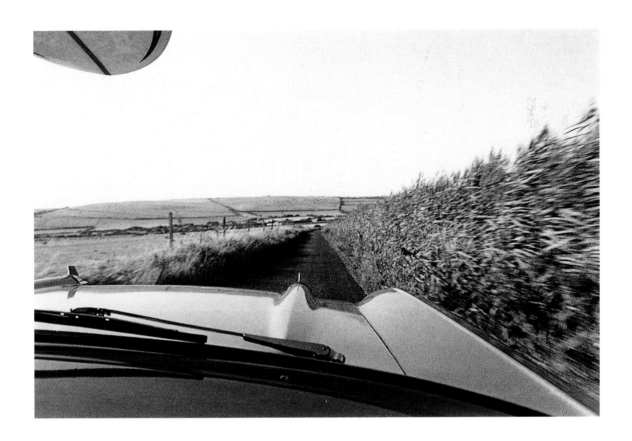

Country lane

Unexpectedly having the use of a 1950s Chevrolet I decided to take advantage of the wonderful lines of the car by shooting the landscape from inside. I took a number of shots but we were continually on the move so I had no time to stop and think. Instead I simply went through my routine and waited for a composition I liked to present itself as we cruised along the country lanes. I felt it was appropriate to convey a blur of movement, so I set a relatively slow shutter speed of 1/30 sec. If you're tempted to try something similar from inside a car, one invaluable tip is make sure the windscreen is clean before you start.

35mm SLR camera, 28mm lens, yellow filter

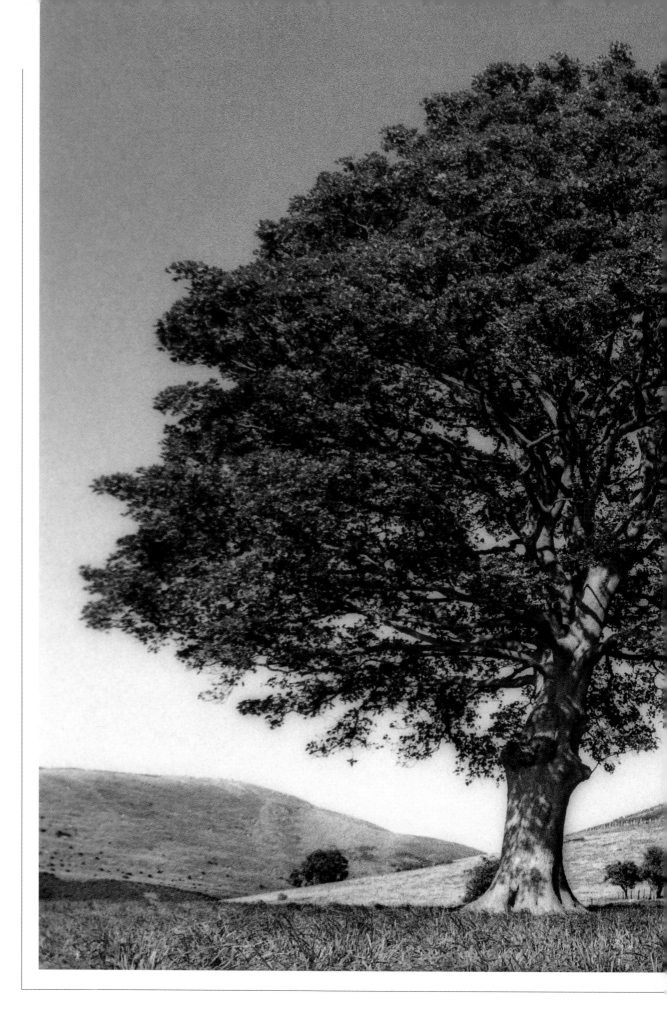

Lenses and Accessories

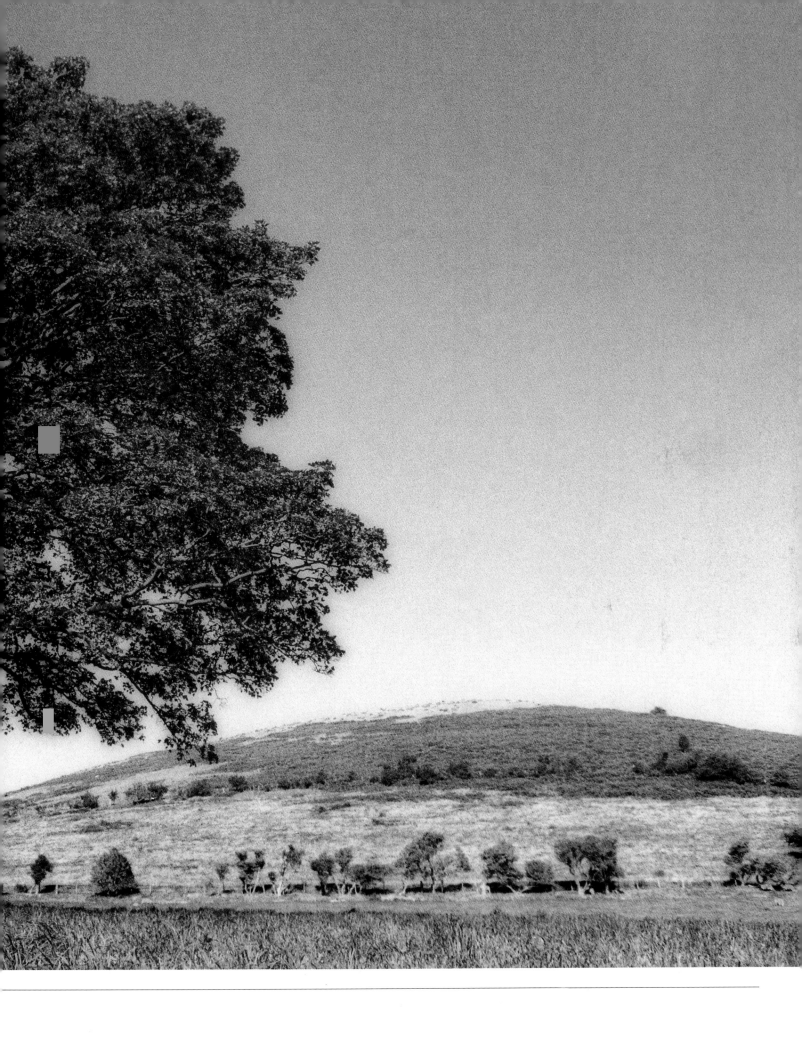

Lenses and Accessories

11 Use a standard lens for a normal perspective

A standard lens has approximately the same perspective as the human eye with a field of vision of about 45 degrees. The 'standard' focal length varies, depending on the format of the camera. In rough terms the standard focal length is approximately equal to the distance from corner to corner of the negative. So on a 6 x 6cm camera the standard lens is 85mm. For a full frame 35mm camera, however, the standard lens is usually 50mm. The advantage of a standard lens is that it does not distort perspective, making it ideal for still-life subjects and landscapes, as well as recording any image as your eye sees it. It also makes the ideal lens for copy work.

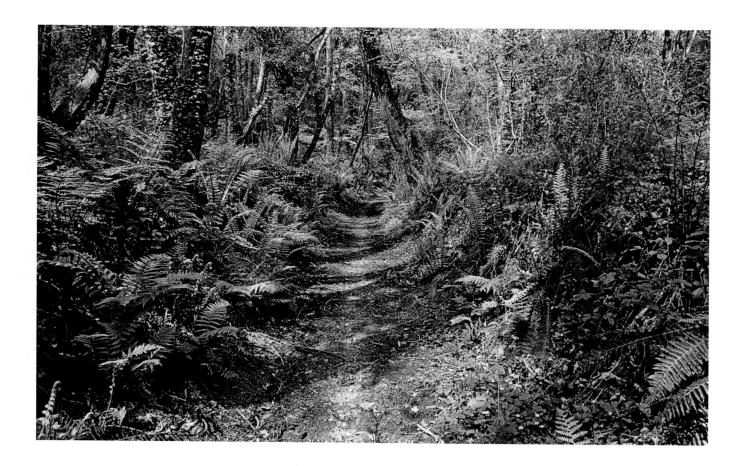

Woodland path

With early morning sunlight breaking through the cloud, the light was not too harsh in this deciduous wood and there was detail visible in the shadowed areas. I set up a tripod and made a composition using a telephoto lens. I wanted to visually accentuate the path as a lead-in but found the composition became too compressed. Changing to a standard lens gave me a wider, more natural perspective; I recomposed and placed the path just off centre to the left so it eventually finished just off centre to the right, creating a sense of balance. I focused about two-thirds of the way along the path and allowed plenty of depth of field.

35mm SLR camera, 50mm lens, green filter

24

12 Add drama with a wide-angle lens

A wide-angle lens will include more in the frame than you would naturally see with the human eye. In order to achieve this the lens distorts the view, exaggerating the perspective as a consequence, which helps to give a photograph the impression of depth. Through the lens, objects close to the camera appear larger, and distant objects become smaller; circular objects will appear oval near the edge of the frame. A wide-angle lens additionally gives a greater depth of field. This means that you can further exaggerate the effect by photographing objects very close to the camera, ensuring that you keep both the subject and a distant background in sharp focus.

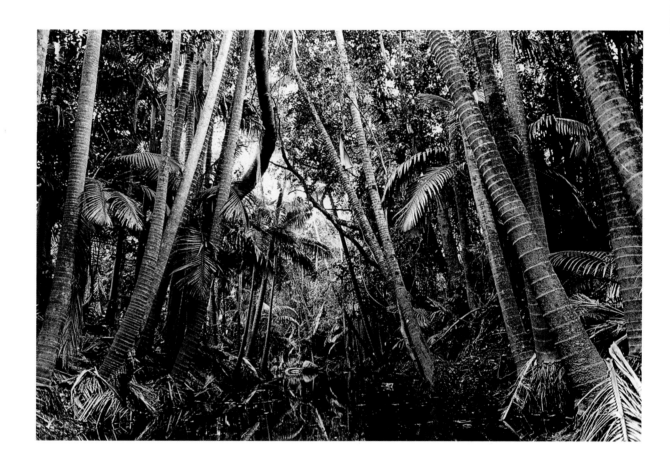

Rainforest

Paddling up a river in Queensland, Australia, I was amazed by the density of the growth and the size of the forest, but it was hard to capture on film. Composing from the front of the canoe, I wanted to get as much of the scene in as possible, and to accentuate the upward sweep of the tall trees and the perspective of the river flowing away to the back of the composition. I used a 28mm lens, aimed down the creek and focused at about half way, using an aperture of f/11 to allow the foreground trees to remain in focus. I metered from the lower section of the photograph, set the shutter speed accordingly, and then let the canoe drift forwards while I made a series of shots.

35mm SLR camera, 28mm lens, yellow filter

13 Compress perspective with a telephoto lens

Changing lenses completely alters the way a camera sees things. Just as a wide-angle lens exaggerates the perspective, making distant objects seem further away, a telephoto lens does the opposite, compressing the space between objects in the scene so they can seem almost on top of each other. This can create some very interesting effects, allowing you to play with components of a scene, stacking them up and arranging them in an almost two-dimensional space. Bearing in mind black-and-white images can already simplify scenes into areas of light and shade, it's possible to accentuate this compressed perspective, playing with our perception of reality using ambiguous blocks of tone.

Bridge

Urban views are good for this type of shot as you can often find lots of distinct objects throughout the scene which can be stacked up, one on top of another, in a compressed perspective. Steel structures like this bridge in Budapest are especially good as you can look through the girders at objects beyond. Having carefully and symmetrically arranged my composition I focused on the near end of the bridge and waited for a tram to pass in the foreground. This gave me my immediate foreground and completes the effect of bustling city life passing back, forth and across itself.

35mm SLR, 200mm lens, green filter

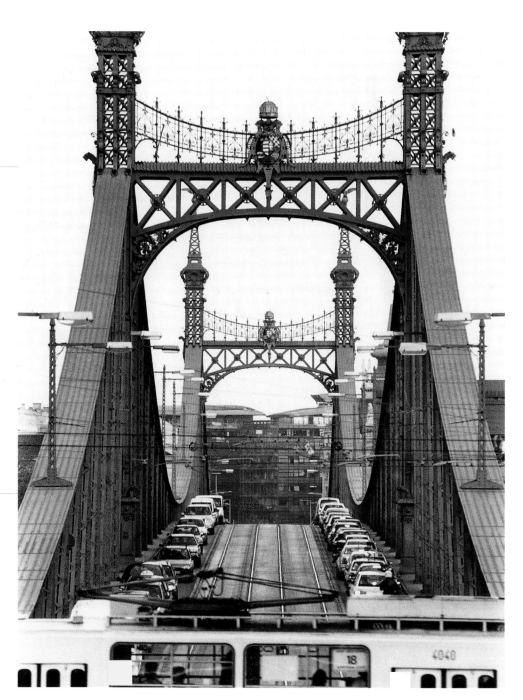

14 Use a green filter

I find a green filter the most useful for landscape photography (assuming it is a predominantly green landscape) and anything including foliage. It will help separate the different densities of green which go to make up the detail of the image. Reds and blues will darken to about the same density as they would using a yellow filter, but not to the extent that they would with an orange or red filter. A green filter also works well with neutral colours such as browns and greys, leaving the colour slightly lighter while separating similar tones and rendering more detail in the image. Allow one stop for exposure compensation if you are not metering through the lens.

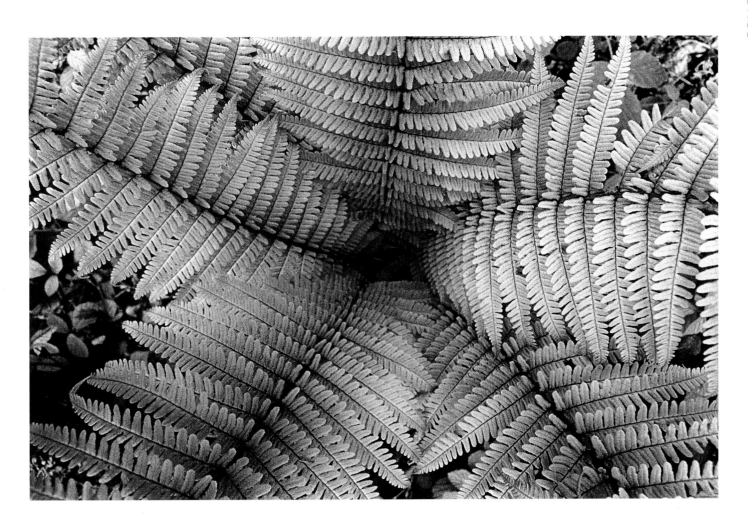

Fern

I found this new fern in an area of woodland in spring. I decided to use a green filter for the photograph as the tones were all basically shades of green and I wanted the subtle differences in tonality expressed. Setting a small aperture to give sharpness throughout,

I used a tripod for accurate framing, and to allow me to use the slow shutter speed I needed to maintain the aperture setting.

35mm SLR, 28mm lens, green filter

27

15 Use a fine film for detail

Fine films have a tighter grain structure than a fast speed film; the silver halide crystals are smaller and the detail in a photograph will therefore be sharper. 25 or 50 ISO film is best used with a tripod when the subject is well illuminated and fairly static, and when resolution and image quality are important. A fine film can produce exceptional quality prints especially on the larger camera formats, allowing you to effectively blow the image up to enormous sizes. The detail available is a useful tool when you want to make close studies of objects.

Old caravan

I came across this old caravan on a country walk and was immediately fascinated by the shabby and peeling textures. Working in late afternoon sunshine I chose a viewpoint that would mix the complex shadows of a tree with the speckled surfaces of the caravan to form a complex pattern. A slow film helped to show up the detail and I had to use a slow shutter speed to maintain depth of field throughout the picture. The wheel provides the point of interest, and I took meter readings from the side of the caravan to calculate my exposure.

35mm SLR camera, 28mm lens, yellow filter

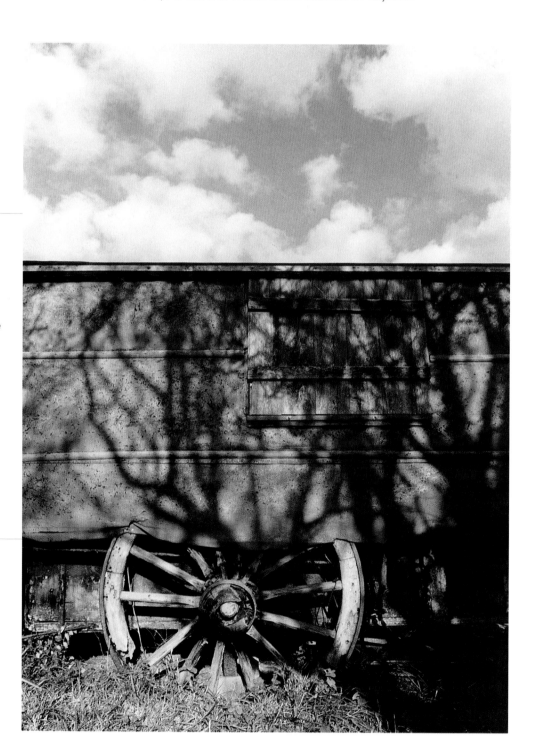

16 Different filters, different effects

Although the eventual image contains no colour, monochrome photography is best produced using a series of coloured contrast filters to control the way natural colour records in black and white. The main types of filters used are yellow, orange and red. A filter lightens its own colour and darkens the complementary colour, for example a yellow filter will lighten yellows and darken blues. You can use contrast filters to lighten or darken certain colours in a scene in order to create differences between colours that would otherwise be reproduced as nearly the same shade of grey. A red apple and green leaves that are equally lit would reproduce as the same tone of grey; to provide separation between the two, a red filter would lighten the red apple and darken the green leaves. The lightest contrast filter is yellow, then orange and red, with a light loss of about 1, 2 and 3 stops respectively. This must of course be allowed for if you are not using your camera's through-the-lens metering.

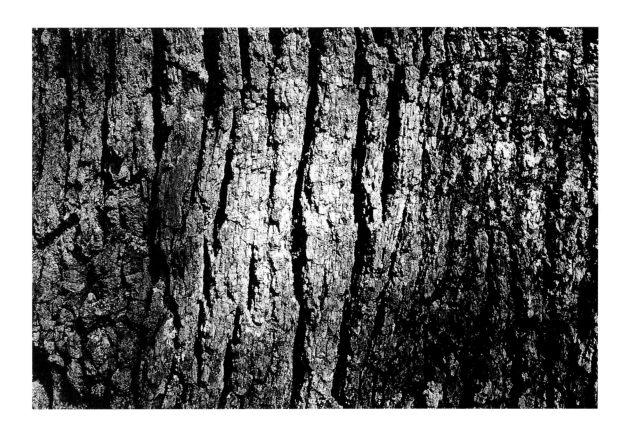

Oak bark

On an early spring day I noticed this splash of sunlight on a tree and found the quality of light was fascinating. I liked the delicate bark structure and wanted to control the contrast as the highlight was quite harsh so I fitted a yellow filter for minimum contrast (orange or red would produce too strong a contrast), and this allowed the colour spectrum to separate and produce a tonal range from the moss and bark. I metered from the bright area and used a small aperture to make sure the whole curvature of the tree was in focus.

35mm SLR camera, 50mm lens, yellow filter

17 Try a fast film for grain

If you haven't gone digital yet, and devotees of black-and-white photography will no doubt be the last, you are probably using a negative film – a light-sensitive emulsion coated on a transparent plastic base. Films are available in different speeds judged by the ISO rating from 25 (slow) to 800 or even faster. The extra film speed is achieved by increasing the size of the light-sensitive silver halide crystals in the emulsion's coating; because of this the faster films appear more grainy. Fast film is commonly used for action photography, where a fast shutter speed is needed, or where the light is particularly dim and it is impossible to use a tripod, but the grain can work to your advantage if you use it creatively, producing interesting and atmospheric pictures.

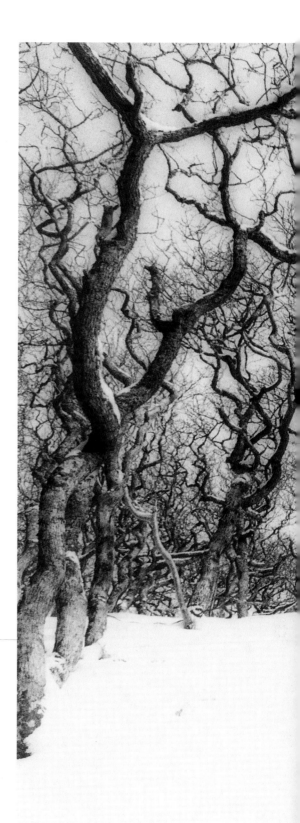

Scrub oak

Walking through an area of woodland in the middle of the winter, I was struck by the beautiful shapes of the oak trees. The branches seemed to interweave with each other and stood out starkly against the whiteness of the snow. I took a light-meter reading from the branches and sky so as to establish the brightness range of the scene, focused about two-thirds into the wood and made a series of shots. There was no need to use fast film from the point of view of the light available, but the extra grain enhances the atmosphere of the final image.

35mm SLR camera, 28mm lens, yellow filter

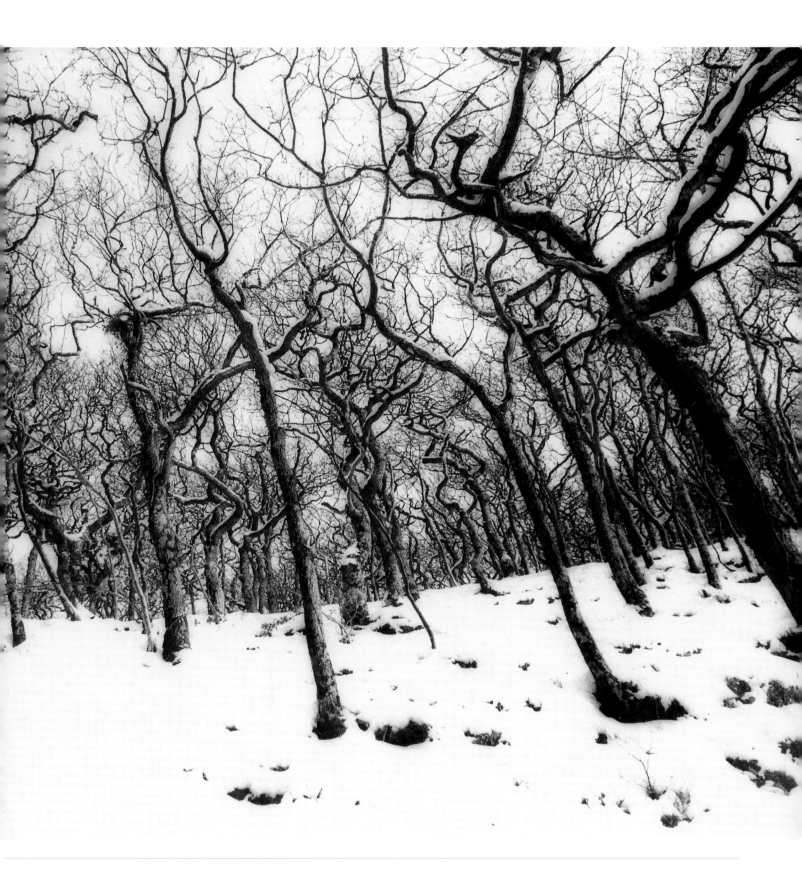

18 Use a polarizer and red filter together

A polarizing filter can be very effective for black-and-white work. Use a polarizing and red filter together and you can achieve an effect which is similar to using infrared film: blue sky records almost black, and clouds appear almost pure white. This effect has limited uses, but with the right subject such as old ruins, seascapes and cloudscapes, it can be most dramatic. When using the two filters together, light compensation of 4 1/2 to 5 stops is needed though most cameras will allow for this if they have TTL (through-the-lens) metering. You will probably need a tripod.

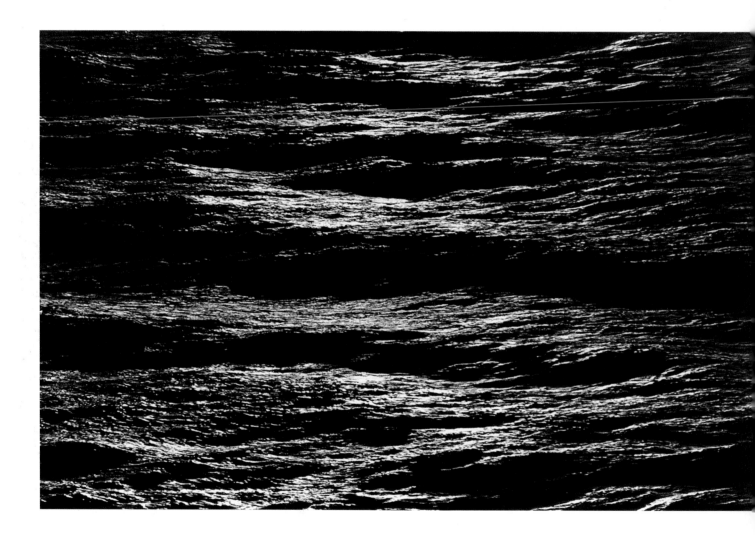

Seascape

Viewing the sea from a cliff top on a stormy winter's day, the late afternoon sun was a line of light across the sea, and with a big swell running this made for an interesting subject. Setting up a tripod with a telephoto lens, I viewed first through a red filter but felt I could further help the image by using a polarizing filter to control the amount of flare from the reflection of the water. Using the two filters in conjunction, with the red filter on the front, I rotated the polarizing filter to eliminate flare and also control the tone and texture of the photograph.

35mm SLR camera, 200mm lens, polarizing filter and red filter

Use a tripod for accuracy

One of the things that distinguishes the professional photographer from most amateurs, is that the professional will usually use a tripod. A tripod will eliminate camera shake. Learning to hand-hold steadily is worthwhile, but even a fast shutter speed of 1/250 sec will not guarantee a completely blur-free image. I recommend using a cable release with a tripod to make sure there's no chance of your carefully positioned camera moving. A tripod also allows you to use slow shutter speeds, small apertures for greater depth of field, and any combination of filters. It is easier to accurately frame and compose your image and you have the advantage of being able to work in low light conditions. The only disadvantage is if you want to cover some distance on foot – they can get heavy after a while – but with carbon fibre tripods and monopods on the market, you can reduce the weight and still retain the strength and rigidity.

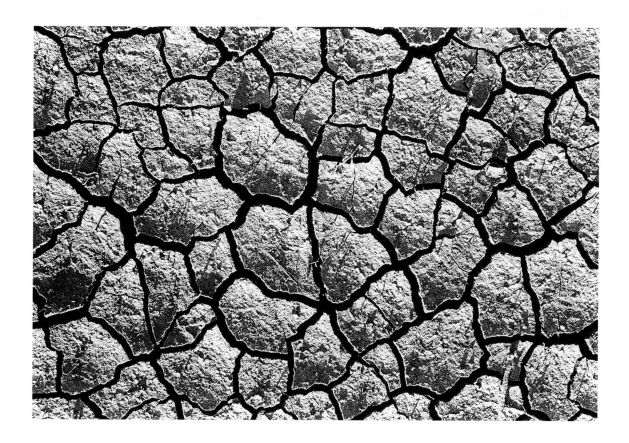

Cracked earth

I was walking in an area of saltflats in Queensland, Australia. It was late in the day and the excellent low sunlight made dark shadows in the cracks of the dried mud. It looked barren, but on closer inspection I saw there were tiny blades of grass growing up. I decided to photograph the pattern and texture of the ground, and as the picture would be all about the way the pattern was arranged in the frame, I mounted the camera on a tripod and carefully framed exactly the composition I wanted, using a cable release to make the exposure.

35mm camera, 28mm lens, orange filter

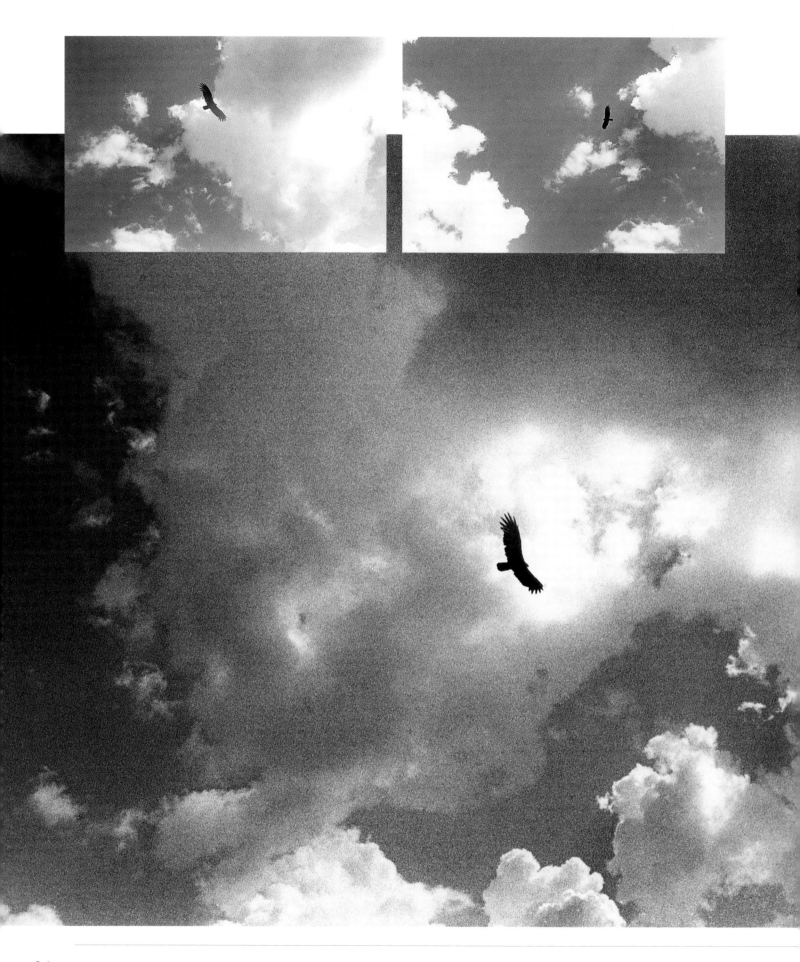

20 Autowinds and motor drives

There are circumstances when the best way to get a great picture is to fire off a sequence and pick the best one. The obvious examples are moving subjects and situations over which you have no control, such as wildlife or photojournalism. A handy accessory is either an autowind, which is often built into newer cameras, or a motor drive. Each will automatically advance the film to the next frame and cock the shutter. The speed of advance for an autowind is about two frames a second, and for motor drives it is about four frames a second. You can take either single exposures or a sequence of exposures as fast as the winder resets the camera. With the camera automatically winding on you can keep it to your eye and continue to concentrate on your subject, not having to recompose after each exposure; this is especially useful when using a telephoto lens.

Sea eagle

Sitting on an headland on the coastline of Cuba, I noticed a sea eagle circling the area. I fitted an autowind to the camera and waited for the next fly-past. The eagle was around twenty to thirty feet above the ground when passing overhead, so I set the light meter and shutter speed, pre-focused on infinity and waited. Following the flight through the viewfinder I made four exposures in rapid succession, then rechecking the light reading and focus, shot another four on the next approach. Having eight exposures of the eagle in different areas of the negatives gave me a good choice to print from.

35mm SLR camera, 28mm lens, orange filter

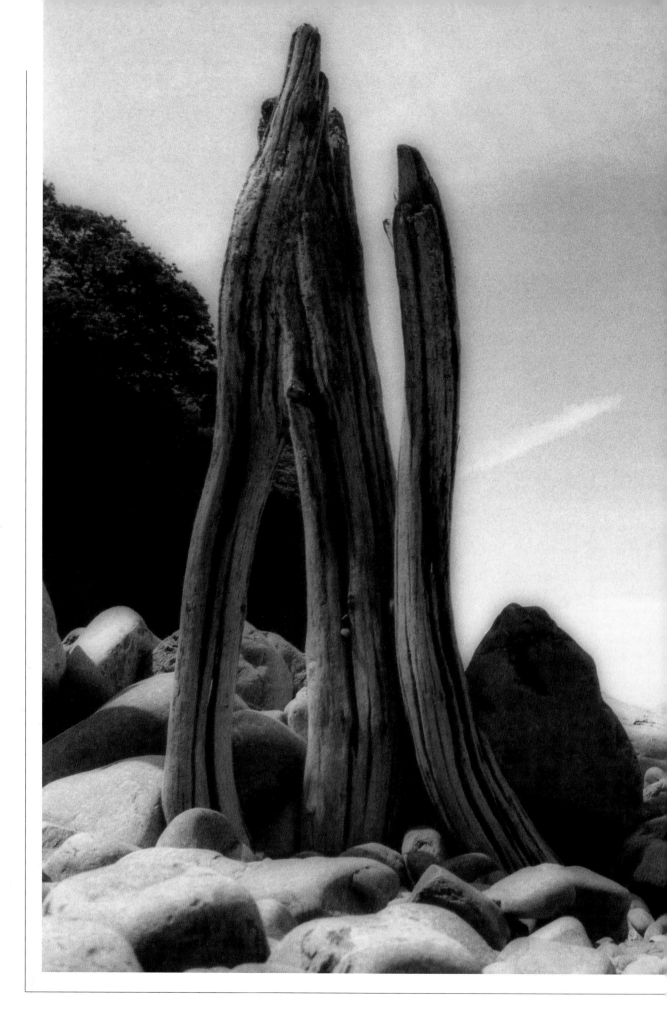

Composition

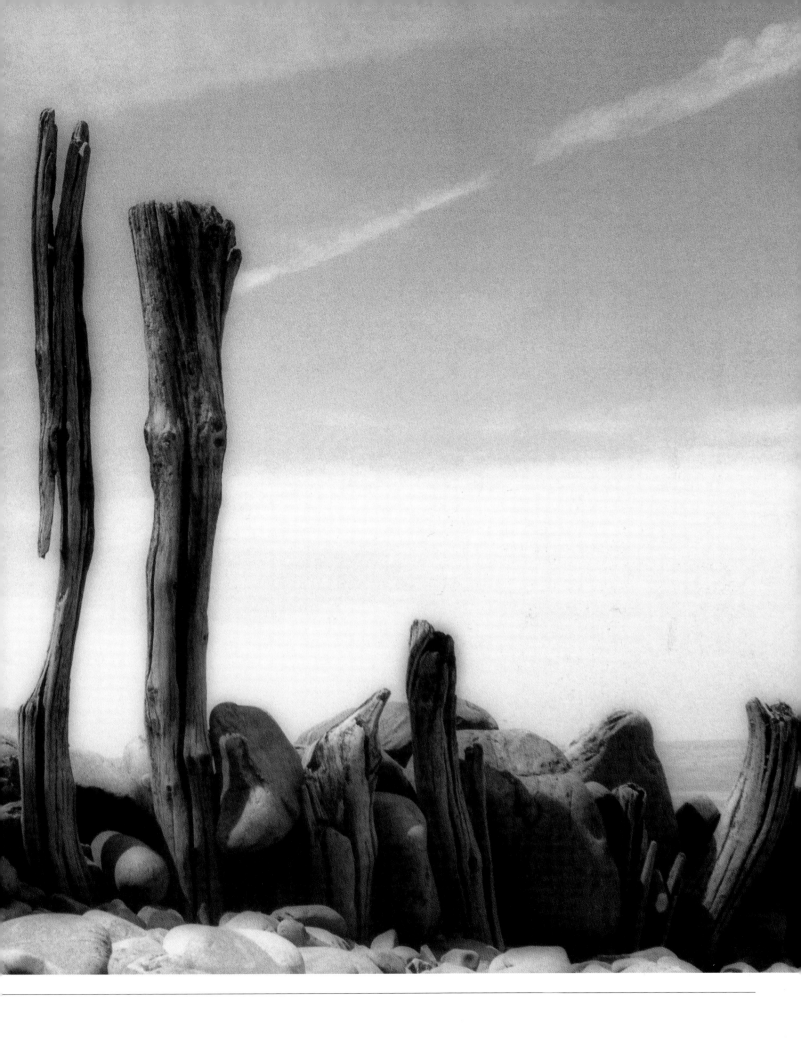

21 Use strong graphic lines

The skilful photographer is able to arrange subject matter in the frame in such a way that the eventual two-dimensional image is both striking and compelling, and draws you into the frame, not simply a representation of the subject but transcending it to become something in its own right. Because black-and-white photography relies on tone rather than colour, using graphic lines and shapes in the composition is even more important. Leading the eye across or into the image, these lines direct the viewer and create drama and overall balance. Disappointing photographs are often the result of including too many conflicting elements, so keep your composition simple and look for strong graphic lines as the first step in selecting a composition.

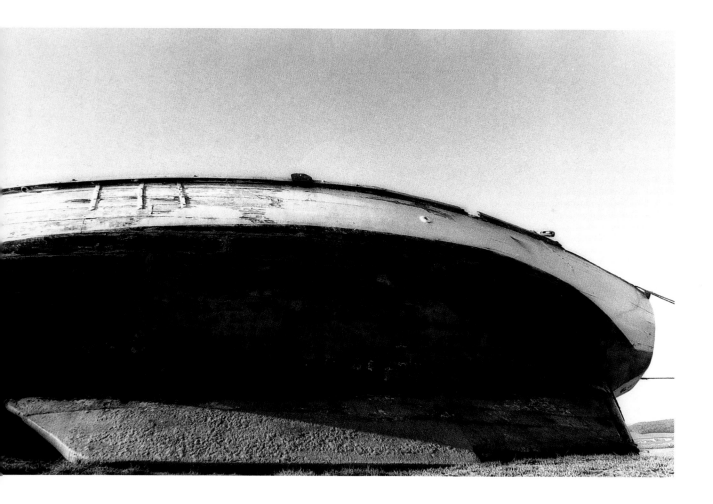

Old yacht

I found this old yacht moored in a river estuary. Admiring the lines of the boat I started to look for a composition, making a few exposures first of the front of it, then moving around to the side. I used a low viewpoint concentrating on keeping the shape of the yacht level in the viewfinder. Arranging the compositional elements in the frame, I let the top line of the boat lead the eye across the image and around to the base of the boat, finishing in the light area of the keel.

35mm SLR camera, 28mm lens, yellow filter

22 Move in closer to your subject

Many photographers find that their pictures often include more of the scene than they had intended when they pressed the shutter. Some cameras have a safety margin built into the viewfinder so that it actually shows a significantly smaller area than will appear on the film, but even without this it's all too easy to concentrate on the subject, amplifying it in your own mind and failing to take account of the other elements within the frame. Moving in really close to your subject allows you to fill the frame, excluding the less important or distracting background details, and is a sure way of creating an eye-catching impactful image.

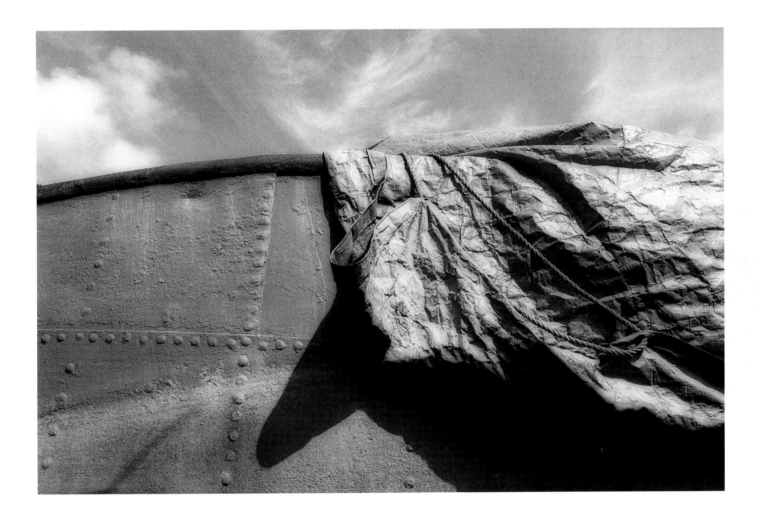

Riveted boat and tarpaulin

Ankle-deep in mud on a riverbank in the August sun, I found this old riveted barge (indicating that it was made before welded boats) covered with a new plastic tarpaulin. I liked the juxtaposition of the old steel and the modern plastic, and the strong shadow area created by the tarpaulin added graphic interest. Moving right in close I balanced the composition of the boat, the tarpaulin and a section of sky (providing some light at the top of the image). I then took a meter reading from the side of the boat and the sky, letting the shadow area fall away to darkness.

35mm SLR camera, 28mm lens, orange filter

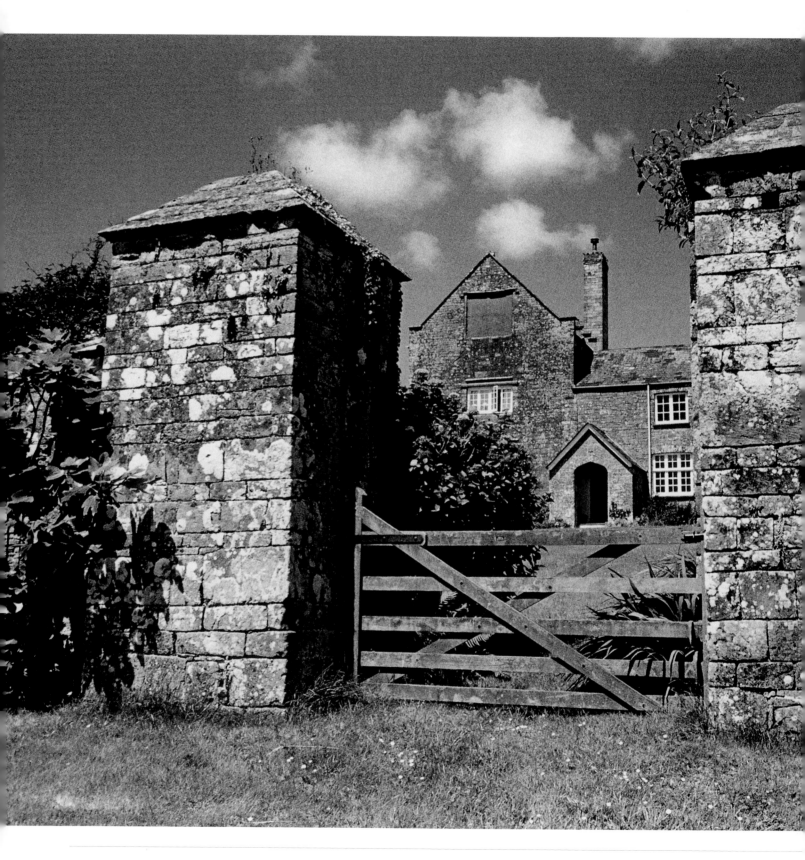

23 Use a strong centre of interest

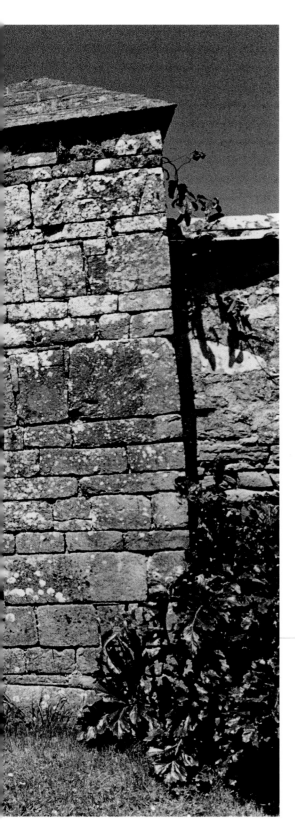

I believe a photograph can tell only one story successfully so I try to establish a strong and unequivocal centre of interest. This can be something obvious like a building in a landscape but could just as easily be something less tangible such as a prominent shadow or highlight. You may want to include a secondary subject or other points of interest within a composition, but make sure that they complement rather than compete with your main subject, and are in some way subordinate to it.

Farmhouse

The doorway of this English farmhouse is actually quite small in the frame and there are several other features of interest in the picture. But there is no doubt that the focal point and centre of interest is the dark porch doorway; the eye is drawn to it from all parts of the picture. I used the gateway pillars to frame the house and placed the doorway right in the centre of the image. Using a small aperture to keep total sharpness from the foreground gateway to the doorway was also imperative.

35mm SLR, 28mm lens, green filter

Composition

24 Explore the subject from every angle

At popular tourist destinations everybody seems to stand in just about the same place to take photographs and inevitably all produce similar images (which are often the same as the postcard). Finding the best viewpoint is a major factor in successful photography and you should try to explore all possibilities before deciding how to frame an image. Once you have looked at the obvious, shift your position, even to the extent of transferring the emphasis entirely from one point of interest to another. Exploring different angles of view, different emphases and different points of focus within a composition allows for endless possibilities and a greatly increased chance of getting a satisfying and original image.

Scarecrow

The moment I saw this scarecrow, I knew at once that there was a photograph waiting to be taken and went to explore all the opportunities. I shot a series of more conventional images, full length with some field foreground detail before settling on this half-length portrait composition. The low viewpoint crops out the field entirely and uses the blue sky as a clean background. In this photo, the absence of a context for the scarecrow makes it an unusual and ambiguous image.

35mm SLR camera, 28mm lens, orange filter

25 Turn the camera upright

Framing in portrait format is often neglected because most cameras are easier to handle in the horizontal position. Even with a tripod, using a camera in the upright position is more awkward and it is all too easy to simply use the camera as it most naturally falls under the fingers, and never consider whether the image might work better as an upright. It is therefore worth making a conscious effort to always consider whether your subject would be better served by upright framing before settling on a horizontal composition. Then at least you know you have considered the options and made a positive decision. You will be surprised how much more often you frame things as an upright.

Old van

The oddness of this old van sur-rounded by undergrowth made an obvious subject and having decided to frame it head on, the use of an upright format was equally obvious. Framing the van horizontally would have given me lots of uninterest-ing space on either side and would have diminished the impact of the photograph. Moving in to fill as much of the frame as possible, I wanted a balanced composition so I raised my position slightly and focused on the front of the van, metering on sky, ground and van.

35mm SLR camera, 28mm lens, yellow filter

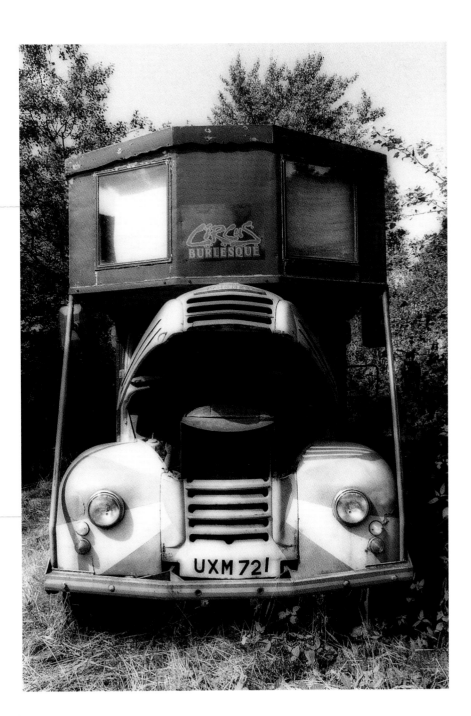

26 Create a sense of balance

A pleasing photograph will naturally have a sense of balance in its composition; it might not be immediately obvious how this is achieved, we just know it when we see it. I believe that balance is achieved if conflicts are eliminated and all elements in the picture contribute to the whole and support one another. So carefully consider each element in your composition and how the component parts interrelate; not just the subject, but areas of shadow, highlight and prominent line. Use compositional tricks such as the rule of thirds, graphic shapes and lead-in lines, but most importantly make sure that all the elements in the photograph are working together harmoniously.

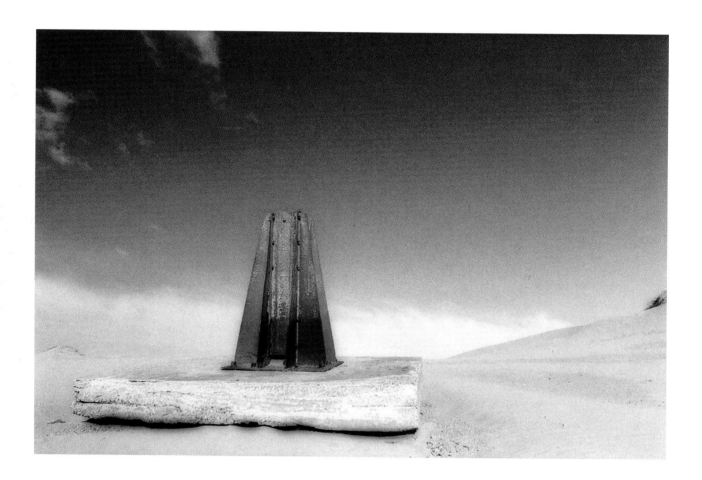

Barrage balloon anchor

Out walking across sand dunes, I stumbled over this obelisk (I later found out it was a barrage balloon anchor left over from World War II). It reminded me of the black monoliths in *2001 Space Odyssey* and I liked its isolation in amongst the dunes. I did not go too close straightaway as I did not want to disturb the sand immediately around the anchor. Choosing the viewpoint carefully, I composed slightly below eye level, placing the anchor to the left of the image, which allowed me to position the top right corner of the concrete base at the point where the sand and the sky dissect, thus making a connection of all three elements. This produced a sense of balance.

35mm SLR camera, 28mm lens, yellow filter

27 Use a low angle

Good photographs often depend on selecting an interesting angle, and the simple act of coming down from eye level is often overlooked. Most photographs are taken from the standing position because when you see the subject you are usually standing up. However, looking for a low viewpoint can be very effective, creating a more unusual image and often adding a sense of drama. If you really get down low you will also have the option of using the sky as an uncluttered backdrop, and with landscape photographs it will foreshorten the foreground. A useful device on some 35mm SLR cameras is a removable viewfinder, which allows you to place the camera on the ground and view the focusing screen from above.

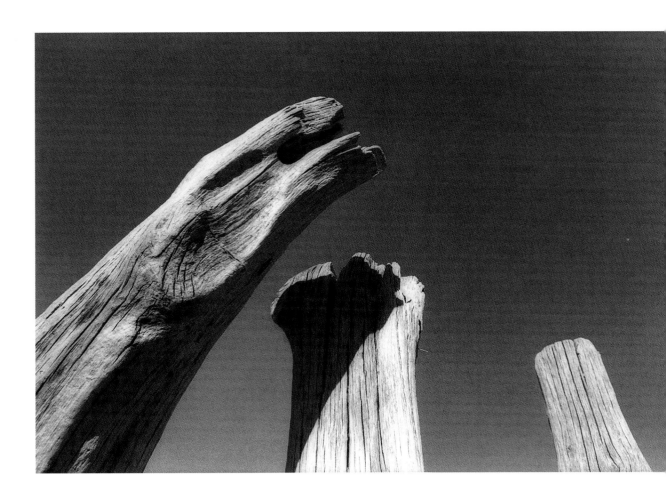

Weathered groyne

A favourite subject of mine and one that I return to regularly are the wooden groynes found all along the coastline of south-west England. I find the time- and weather-ravaged appearance of these structures endlessly fascinating. Returning to a favourite location and looking over a line of ruined groynes, I found a low viewpoint allowing me to crop out all distractions and frame the wood against the sky. I let the main timber to the left of the photo dominate, and its shadow confirms this as it cuts across the second timber, allowing the third piece to balance the right side of the photograph.

35mm SLR camera, 28mm lens, red filter

28 # Make a point

In the making of photographic images, the photographer has the power if not to change he way things appear, then to manipulate them to his own ends. By altering your point of view – the relative prominence of objects in the frame and their relationship with each other – it is possible to say something more than simply 'here is a representation of a subject'. By deliberately juxtaposing incongruous elements or manipulating the situations of objects it is possible to give meaning to your photographs, from comical juxtapositions to serious political comment.

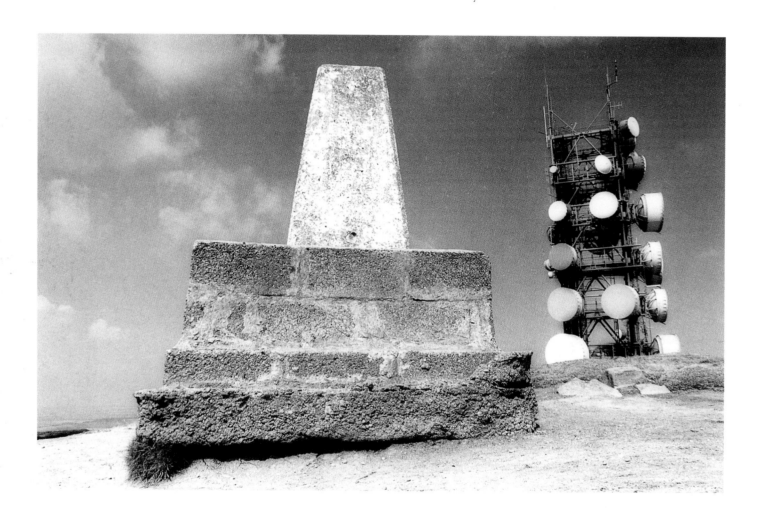

Old technology meets new

This is an old triangulation point for map making, and immediately behind it I found a new communication tower crammed with relays. I liked the irony of the old technology and the new choosing the same spot and decided to frame the image so that the old concrete platform became the dominant structure in the composition with the new tower growing up behind, as if ready to take its place. I took light-meter readings from the ground, the side of the structure and the sky, and focused on the side of the platform allowing plenty of depth of field so the tower would remain in focus.

35mm SLR camera, 28mm lens, orange filter

29 Use the rule of thirds

Imagine two horizontal lines cutting the photograph into thirds and two vertical lines cutting the same image into vertical thirds. According to the 'rule of thirds' the intersection of these imaginary lines suggests four possible options for placing the centre of interest, any of which will result in a balanced and harmonious picture. In reality every composition presents its own unique problems and I would advise dealing with each situation on its own merits. Creating the most balanced composition is more important than strict adherence to the rule, but awareness of this simple system can be enormously helpful.

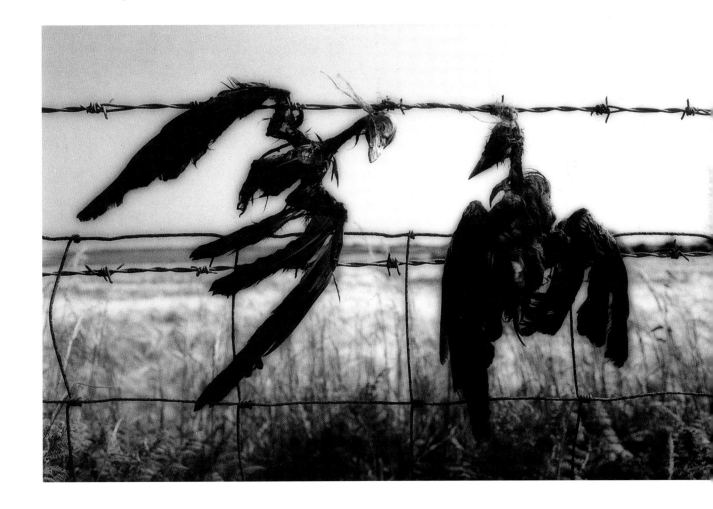

Two dead crows

I found these two crows strung up on a fence in Wales. They had been placed there by the local farmer to deter other crows from feeding on the crops in the field. This is an unusual example of applying the rule of thirds: the wire fence roughly divides the picture into horizontal thirds and the two crows sit across our two imaginary vertical lines, so the subject of the photograph actually straddles all four points of intersection of the imaginary lines. Taking a meter reading from the background, I set the aperture open for a limited depth of field.

35mm SLR camera, 28mm lens, green filter

30 Watch the background

The background can make or break a photograph. It can help set the mood of the image and support the subject, or it can fight with it, drawing attention away from the subject and ruining the image. Beware of objects immediately behind your subject and watch out for obstructive elements or actions going on in the background that do not relate directly to your subject and are likely to divert the viewer's attention. Shifting your position just a little can often eliminate the problem very simply, but always remember to consider the background carefully, because even if you try to ignore it, your camera certainly won't.

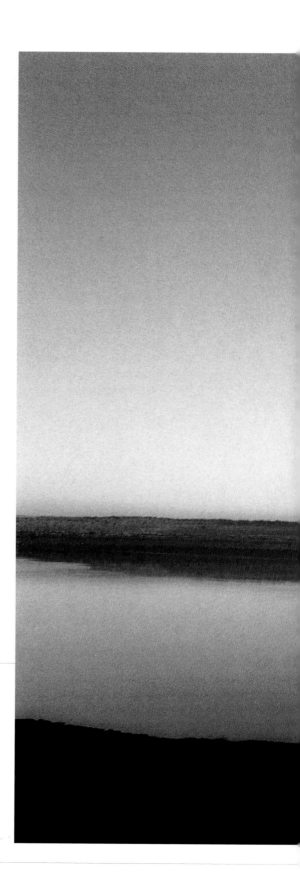

River channel marker

Walking along a river bank I noticed, every few hundred metres, a channel marker for guiding the local boats up and down the river. I liked their rough home-made construction from a plastic drum and clay pigeon shooting disc which looked rather abstract, and I decided to photograph one. I got down low and started to look for a natural point of view to frame. Placing the pole to the right of the photograph, I deliberately placed the one feature in the background, the small pillbox on the horizon, just off centre.

35mm SLR camera, 28mm lens, orange filter

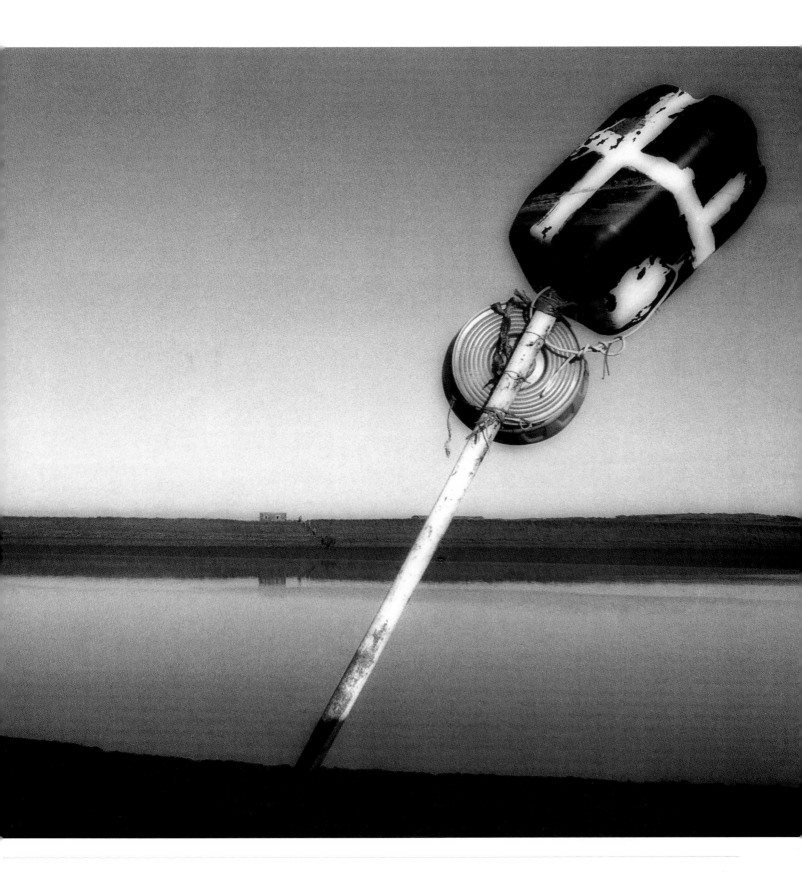

31 Look for the incongruous

If things are not where they should be or where we expect them to be, we tend to sit up and take notice. Incongruity fascinates and amuses us. From slapstick comedy to surrealist art, something or someone out of step with their environment has provided the material for a great variety of art and entertainment. In photography subject matter is easy enough to find as we have the advantage of including in the frame only what we choose, so even if the unusual juxtaposition is not immediately obvious you can draw attention to it through your composition. You may come across oddities that are photographs waiting to be taken, but you can also exploit situations by searching out people and objects at odds with their environment and emphasize the clash in the way you frame your picture. It could be something as simple as someone drinking from a can of Coke in front of an advertisement for Pepsi.

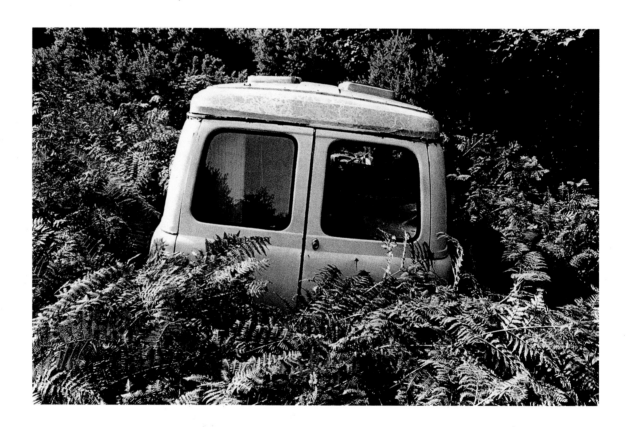

Van and bracken

Walking in the Devon countryside and emerging from some woodland I was surprised to find this old van abandoned and being swamped by undergrowth. There was an oddness to the van being so out of its natural environment, and the windows reminded me of two big eyes, like those of an owl. I used a straightforward viewpoint of the back of the van, showing just a simple shape. The afternoon sunlight was quite harsh and to help control the contrast I used a green filter, which lightened the foliage.

35mm SLR camera, 28mm lens, green filter

32 Make use of pure black and pure white

Although it is often the goal to keep detail in the shadows and not allow the highlights to completely blow out, sometimes the judicious use of an area of pure white or black, with absolutely no detail whatsoever, is a very effective technique. For example in a predominantly sombre and dark scene, the presence of a reflection or a small window or skylight which appears as pure white, serves as a tonal reference point and brightens the whole image, avoiding the sombre tones appearing muddy and too dark. Likewise an area of pure black within a scene of full tonal variation provides the extreme, and a reference point from which the tonality of everything else can be judged. Taken to the extreme, compelling high-contrast images can be created using special orthochromatic high-contrast film, testing your ability to 'see' in black and white to the limit. The same effect can be easily achieved in post-production on a computer but will rarely make a good image unless it was shot for the purpose.

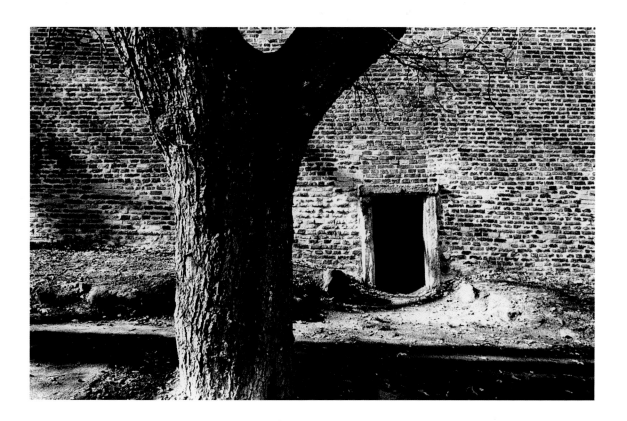

Tree and doorway

This doorway is in the old castle walls in the Hradcany district of Prague in the Czech Republic. The strong sidelighting makes for a dramatic image, and the pure featureless black inside the doorway not only draws the eye and makes it the focal point of the image, but also has the effect of illuminating the deep shadows cast by the tree where detail can nevertheless still be seen. Metering on the brickwork of the wall I made exposures at this reading, knowing that the doorway would record as featureless black.

35mm SLR camera, 28mm lens, yellow filter

Understanding Light

33 Control the contrast

Understanding the quality of light and its direction is the key to good photographs. Different times of the day, seasons and locations all throw up distinct types of light; getting to recognize and control these situations will make a tremendous difference to your pictures. Black-and-white film can only record a limited brightness range. If the differences between the highlight and shadow are greater than the film can record, the result will be dense shadows or burnt-out highlights, resulting in a harsh image. Similarly, if the brightness range is very small, the result can be flat in tonal quality and uninteresting. The first rule of controlling contrast is simply learning to see it and avoiding subjects that will not record well.

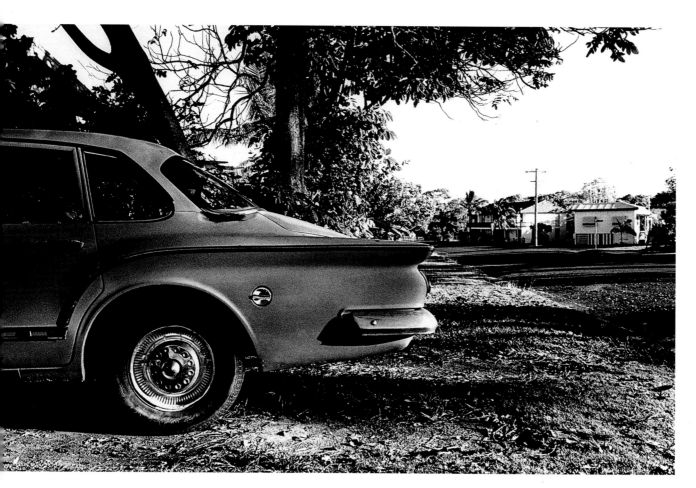

Chrysler Valiant

On a visit to Australia I was in Queensland when I came across this classic 1960s Chrysler Valiant in the local suburbs. Looking over the subject, my first thought was to photograph from the rear of the vehicle, but the sun was in the lens and would certainly have burnt out the details. From the front of the car the background was too cluttered, so I chose a side view where I could control the light. I took an average light reading and closed down one stop so that I could control the highlights but still retain details in the shadow area.

35mm SLR camera, 28mm lens, orange filter

54

34 Exploit shadows

A strong shadow can be just as important a feature in an image as any solid object. It is easy for our minds to ignore what we know is not there, but if you try to see any scene in terms of light and shade, rather than physical objects, you will have gone a long way towards creating successful black-and-white photographs. Look to see where shadows are coming from, how big, how dark, whether they have soft or hard edges. Watch out for areas of shadow which will distract you from the subject, and also avoid situations where the shadow area dominates a large proportion of an image, unless it is fairly soft and you can record the detail on film.

Self portrait

I often take a snap of my shadow in different landscapes just for fun, and walking across a saltflat in Queensland, Australia, I liked the long exaggerated shadow in the empty landscape. In most circumstances I would do everything to avoid my shadow falling across a composition, but to make a feature of it creates quite an interesting self-portrait. The exposure was made after taking an average meter reading of the scene, and I used a small aperture to keep foreground and background detail in focus.

35mm SLR camera, 28mm lens, orange filter

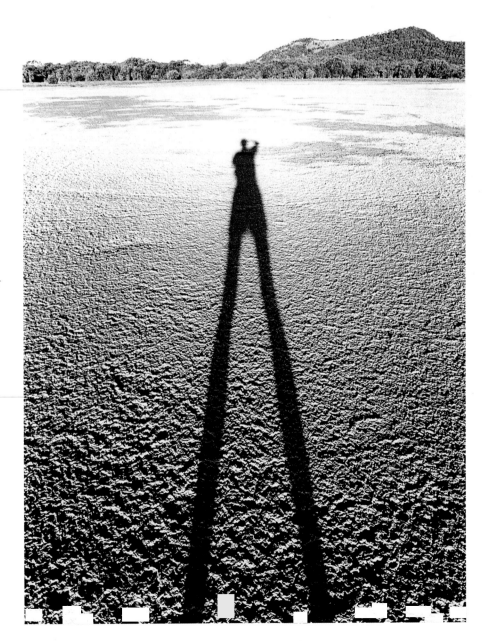

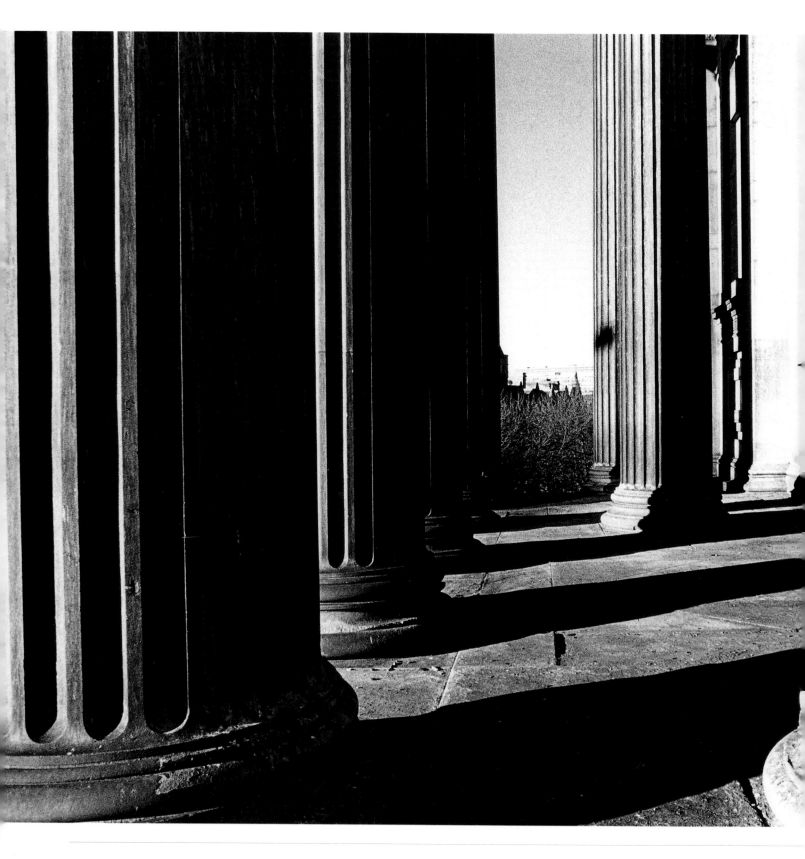

35 Use strong side light

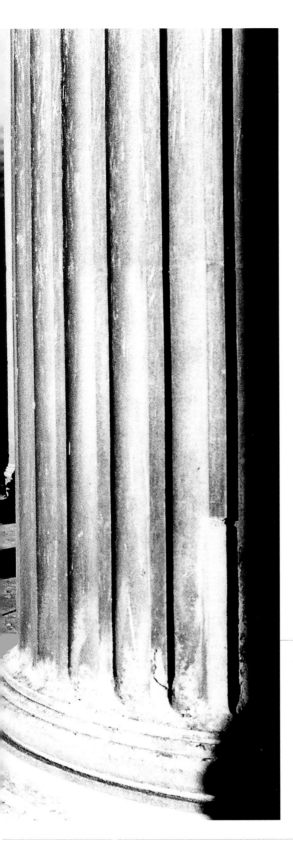

Low sunlight has excellent qualities for photography, providing clear, crisp light and casting long, deep shadows. Turning 90 degrees to the direction of the light will have a dramatic effect, creating strong lines of shadow and accentuating the shapes of objects. The quality of the light is similar but all the shadow details will have changed, making them more prominent in the scene. The usual outdoor photographer's working hours of early morning or evening will catch the best light but in winter you don't have to get up so early and you can shoot with low sun more or less throughout the day. Watch out for flare, though, which can be a problem in low sunlight.

Columns

I first made a series of photographs of this Victorian building in Liverpool from the front, lit directly by low winter sunlight. Changing my position I moved parallel to the columns to frame a viewpoint and found deep shadows creating strong graphic lines in the flutes of the columns, as well as the shadows cast by the massive columns themselves. I took TTL spot-meter readings from the shadow area, the lit area of a column and the sky to establish the extremes of the light and to avoid highlights burning out in such a high contrast scene.

35mm SLR camera, 28mm lens, yellow filter

36 Use the light available

When working in low light conditions resist the temptation to reach for the flashgun – it's not always the best approach to the subject. A flashgun will replace the ambient light and by doing so will completely alter the character of your subject. This can spoil the atmosphere and ambience, which is very often just what you are trying to capture. Choose a fast film that will allow you to use a fast enough shutter speed in low light, try to exclude large areas of strong shadow which won't show detail, and frame the scene in such a way as to have even light. I usually open up one stop from the average TTL (through-the-lens) metering, and avoid metering from the light source itself.

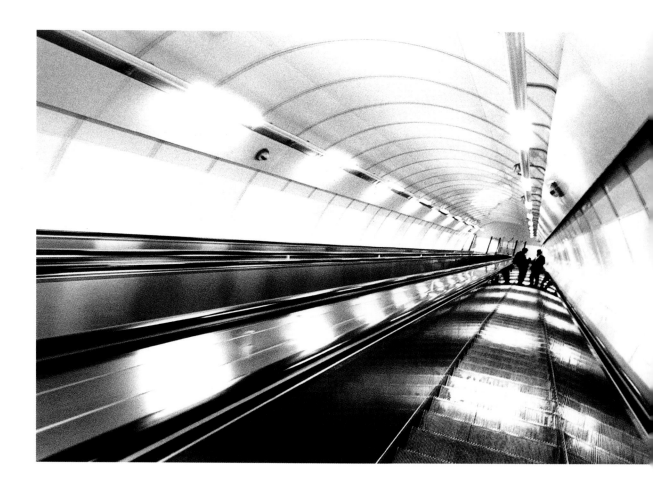

Escalator

Using the metro system in Prague to get around the town, I was struck by the depth of the tunnels and the length of the escalators. The lack of advertising posters gave the wall a clean and very strong graphic line all the way down. Being underground there was only light from the overhead striplights which produced a pattern effect on the metalwork. I used an average meter reading and opened up one stop. The two people in the lower part of the scene gave a sense of scale to the image. I wanted them in focus so used a small aperture, and because of this I had to use a slow shutter speed of 1/30 sec.

35mm SLR camera, 28mm lens, green filter

37 Photograph backlit subjects

Backlighting can produce dramatic images with strong separation between a subject and the background because it creates a rim or halo of light around the subject, emphasizing its form. Solid objects illuminated from behind will produce hard-edged, dark silhouettes, whereas a tree, flowers or foliage can have a translucent quality with the light flooding through from behind. It can be a great way to photograph statues or unusual structures as it accentuates the outline of their form. If you want to record detail in the subject, take a meter reading from it and open up two stops. To take a plain silhouette, simply take the reading and shoot.

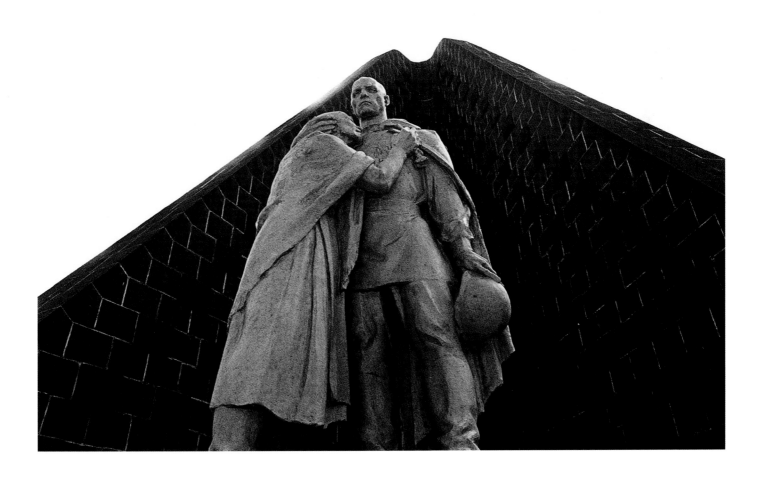

War memorial

This Soviet war memorial statue in Dukla, Slovakia, has an iconic quality and I wanted to emphasize this in my photograph. Photographing from below to accentuate the feeling of monumentality, I hid the sun behind the wall to make a silhouette of it and further add to the drama. Metering from the statue, I opened up an extra half stop, focused around the shoulder of the soldier and allowed enough depth of field to have focus from the foreground through to the top of the wall.

35mm SLR, 28mm lens, green filter

38 Watch out for flare

Even the latest multi-coated lenses are not completely immune to flare and it will still happen under certain conditions. Over the years I have lost several good photographs to this problem and it is certainly something to try to eliminate. Shooting with side- or backlighting is when it is most common – excess light falls on to the camera lens and creates hotspots, the familiar octagonal spots of light. A lens hood cover that will shade the lens is the usual way to control flare – most long lenses have them fitted, but you can use them as standard for all lenses. If the problem is acute, use your hand or a piece of card to throw shadow on to the lens.

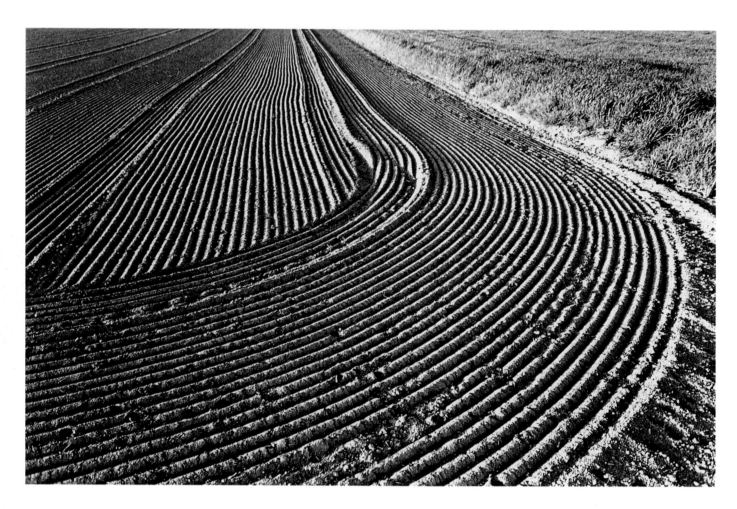

Field pattern

On an evening's walk crossing farmland, I saw these patterns in a recently rolled field. The sun was low on the horizon, shadows were filling the troughs and the light was clipping the peaks of the rolled lines. Framing as I wanted, I found flare entering the lens even with a lens hood cover. So I set the camera on a tripod and recomposed, putting myself in a position where I could block any excess light falling on the lens; I also closed the screen on the viewfinder to eliminate any flare entering the back of the camera.

35mm SLR camera, 28mm lens, yellow filter

39 Shoot on a dull day

It may seem miserable out but often a dull day is ideal for black-and-white photography. Complex subjects such as woodland and architecture that include a lot of busy detail can easily become incomprehensible muddles, with bright highlights and hard shadows increasing the confusion. The soft diffused light of an overcast day makes it much easier to control contrast, and when the sky becomes heavy and moody it can add great atmosphere to the image. Certain subjects are better photographed in dull or soft light, such as a busy street scene or a still life.

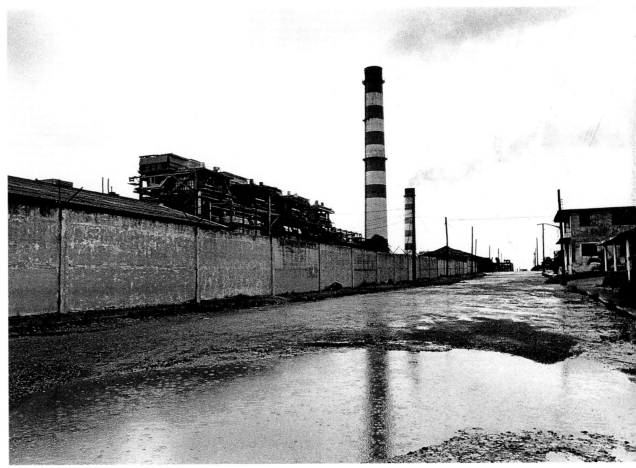

Cement factory

The Cuban sky was crystal clear when I left my hotel early in the morning, but as the day progressed heavy rain showers started. Not to be deterred I carried on trying to shoot some film. Looking around the town and finding the factory perimeter with chimneys belching smoke, the rain and low cloud suited the subject and accentuated the murky, smoky atmosphere of an industrial scene. Finding a viewpoint, I needed good depth of field and used a shutter speed of 1/60 sec to keep the rain on the puddle relatively sharp.

35mm SLR camera, 28mm lens, orange filter

40 Shoot in bright sunlight

When the sun is high in the sky the light is not considered best for photography; however, it is still possible to shoot in direct overhead light and get interesting results. During the middle of the day shadows are short and contrast extreme and the light is often hazy, but it is possible to make a virtue out of these drawbacks and emphasize these characteristics. Look for a composition which does not require the subtle modelling that longer shadows would produce, and where the harsh, flat lighting might emphasize the stark nature of your subject. One advantage of shooting in these conditions is that the bright light will allow you to use fast shutter speeds and gain maximum depth of field without needing to use a tripod.

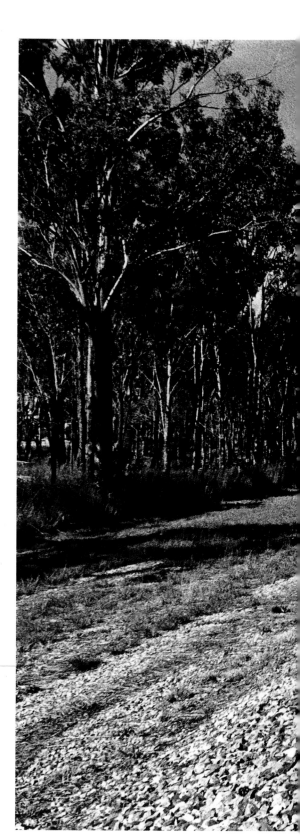

Rail lines

This photograph of railway lines in Queensland, Australia, was taken around mid-afternoon with the sun still over-head but becoming slightly more directional. The railways carry freight over huge distances of harsh and unchanging landscape in Australia and the hard brightness and lack of shadow in the image helps to convey a feeling of the uncom-promising heat of the Australian sun, relentlessly beating down on endless miles of track.

35mm SLR camera, 28mm lens, orange filter

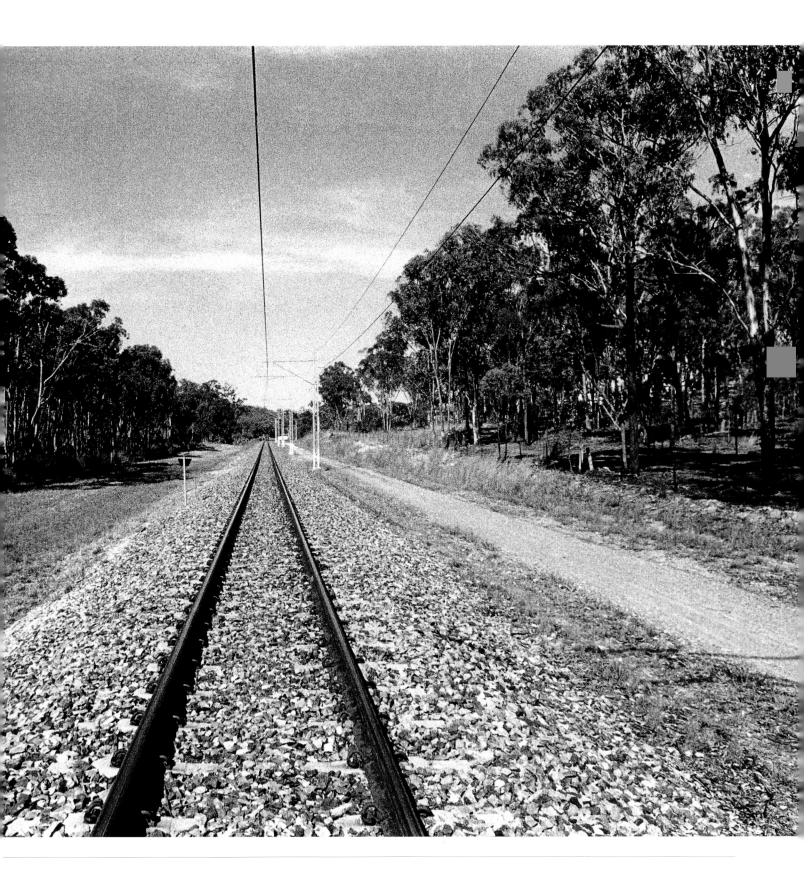

41 Learn to read the sky

The sky can be a compelling subject for photography and it's worth keeping a careful eye on it. Learning to interpret the sky and knowing what the weather is about to do is also a tremendous asset. Understanding the nature of the sky and the prevailing weather is the most obvious signal of lighting conditions, and just by looking up you will know whether the light on your subject is harsh or hazy, direct or diffused. Take note of the direction of the wind and where the clouds are coming from, learn to recognize the types of cloud and try to judge the atmosphere for imminent changes in the weather. Not only will you become more sensitive to how a scene might develop, perhaps revealing the sun or casting interesting shadows on the land, but you will also have a better idea of how the weather will change over a longer period. Perhaps you might be able to anticipate a stunning sunset or see the signs of a serious downpour heading your way.

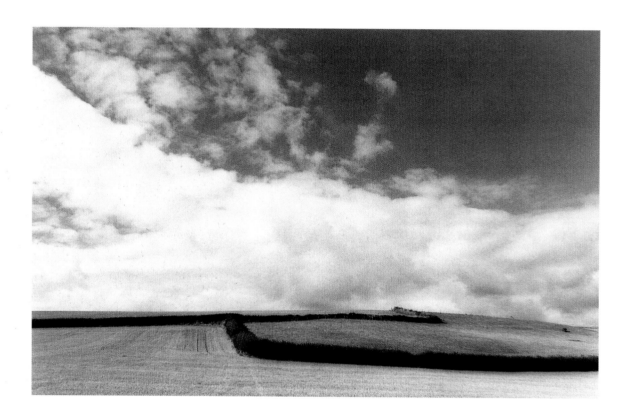

No man's land

October is a time of changeable weather in the English county of Devon as high pressure systems building in the Atlantic cause great cloud formations to pile up over the coastlines of the West Country. On this occasion I noticed the high status cloud building and within half an hour clouds were banking up and the weather front moving in. I framed this landscape using the hedge to lead the eye across the picture, and cropped out most of the foreground to allow the dramatic sky to dominate. I shot just a few frames before heading for home just in time to miss the rain.

35mm SLR camera, 50mm lens, green filter

42 Photograph at night

City views can work wonderfully well at night. Obviously there are problems to overcome when you're shooting in darkness but if you can get the lighting right, the results can be exciting. Street scenes with lots of artificial lighting offer good opportunities for atmospheric images, but uneven illumination and overall low light levels create challenges. We tend to think a street is lit evenly because our eyes are able to adjust to the differences rapidly, but film records everything faithfully and will show up the problems. To calculate the settings take a meter reading of the illuminated areas (but not the lights themselves). A tripod is useful as a long exposure will usually be necessary. These long exposures will cause any movement on the film to blur, while static subjects will remain sharp. Taking an average meter reading under these circumstances will usually underexpose and so it is best to compensate by opening up two stops – if in doubt, bracket.

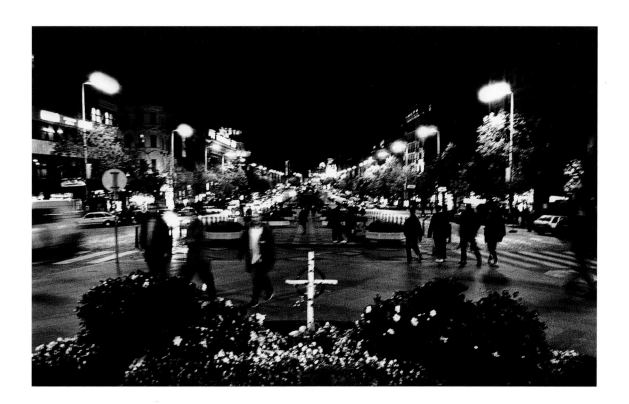

Street scene

I took this photograph of Wenceslas Square in Prague on an autumn evening. When composing I excluded some foreground lighting because it was distracting and this would have taken your eye away from the cross which is the focus of the picture. Taking light readings from the camera's TTL spot meter, I metered on an illuminated area of the pavement and surrounding buildings to calculate the camera settings. A shutter speed of 1/4 sec was needed, which gave a slight movement to the people walking by, and which also adds a sense of atmosphere and bustle in the square.

35mm SLR camera, 28mm lens, green filter

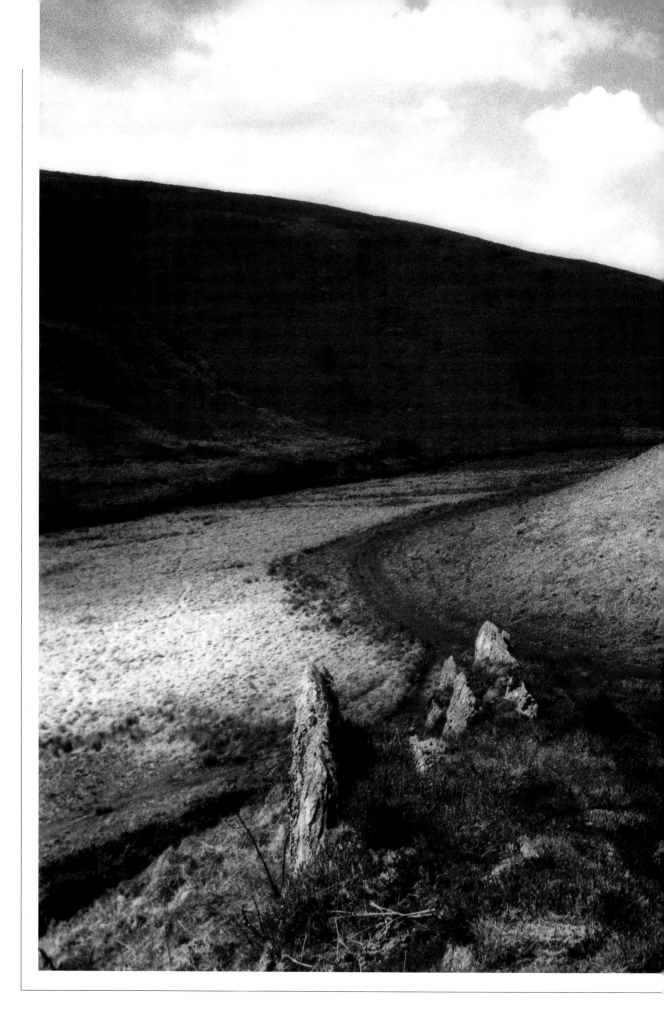

Landscape

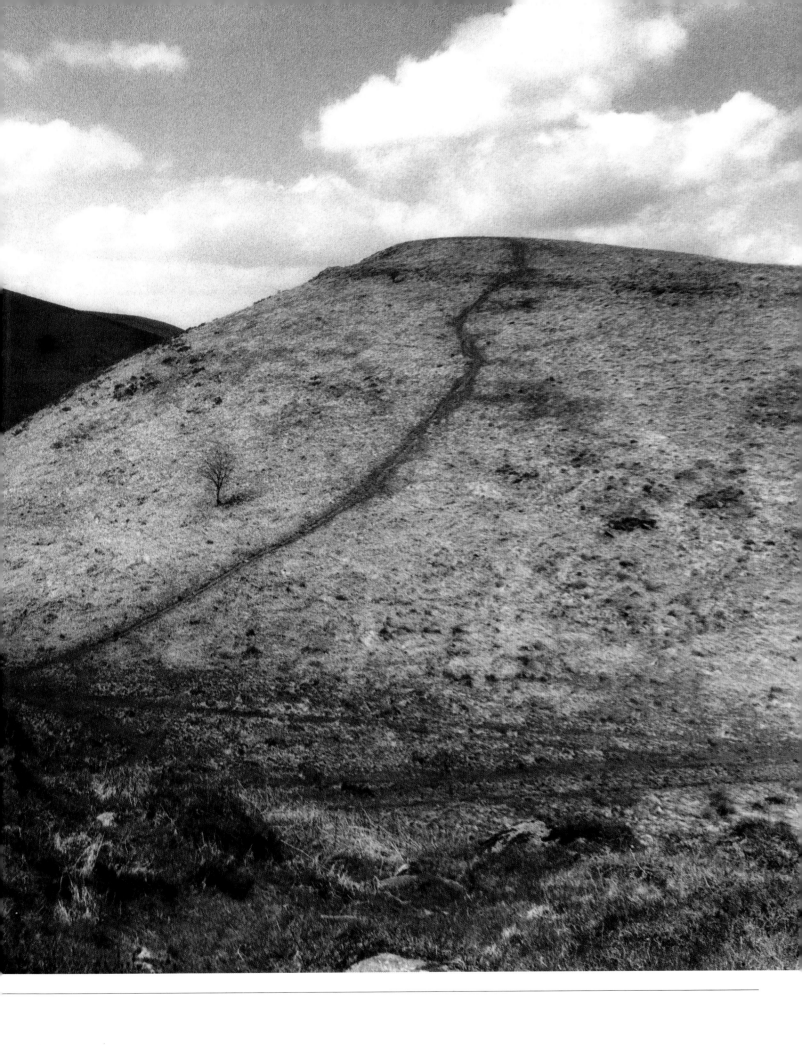

43 Photograph all the year round

Seasonal changes create different moods, and different qualities of light, different tones and colours in the landscape. The same subject can be photographed all year round and will be utterly transformed each season. As the seasons change, the physical qualities of the landscape change radically, most obviously with the foliage following its cycle from spring growth through summer abundance to autumn decay and winter bareness. But at the same time, the light is changing every day, from winter's clear, crisp light offering a low sun throughout the day, to the hazy soft light of high summer. There is always something new and exciting at any time of the year, so make your photography a year-round activity.

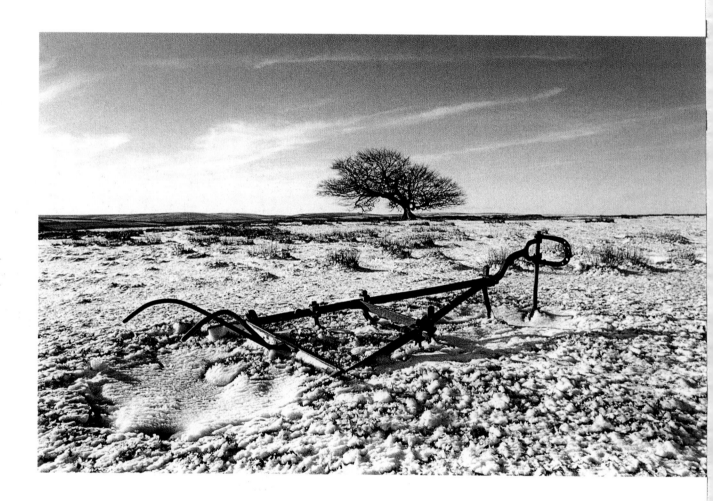

Old plough and lone tree

Winter walking in bright weather offers many photographic opportunities with low sun and clear light defining the subject well. On such a day I came across an old plough in a field and started to look for a viewpoint where I could include the tree in the background, still retain good lighting, and photograph the plough from an interesting angle. Keeping down low for the composition I took an average meter reading of the scene and separate readings of the sky and ground, allowing for the reflection from the snow by opening up one stop.

35mm SLR camera, 28mm lens, orange filter

44 Include man-made features

One thinks of landscapes as natural environments, but in fact, except in the more remote and wild places of the world, it's hard to find a landscape that doesn't include some sort of man-made structure. It is tempting to try to exclude cranes or pylons, to hide artificial structures and present the landscape as it would appear 'naturally'. But in reality most landscapes betray man's influence in some way, in walls, paths, field patterns, buildings – and this is indeed their 'natural' state. So make the most of it, and use man-made features to add interest, give scale, provide a lead-in line, or to add a touch of humour or incongruity to your images.

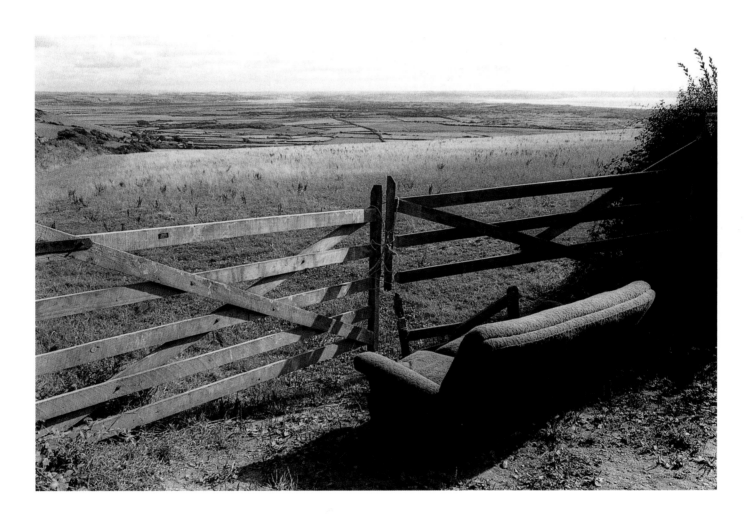

Sofa with a view

This scene in Devon in early summer made me chuckle. I sat down on the sofa for a time and enjoyed the view before making any photographs. The sofa is out of context with its environment, which makes for a humorous picture; it is a playful image because the sofa is itself the subject, but also because it invites the viewer to look out and admire the view that it is facing.

35mm SLR camera, 28mm lens, green filter

45 Use a lead-in

The use of a lead-in line with landscape and other views is an often used trick to draw the eye into the photo and achieve a sense of depth and scale. This is a particularly effective compositional device and the possibilities are all around: paths, lanes, hedges, walls or roads, the furrows of ploughed earth or lines of crops, a river, canal or stream or the strong straight lines of buildings. The effect is more striking when using a wide-angle lens, but standard and longer focal lengths will also be effective.

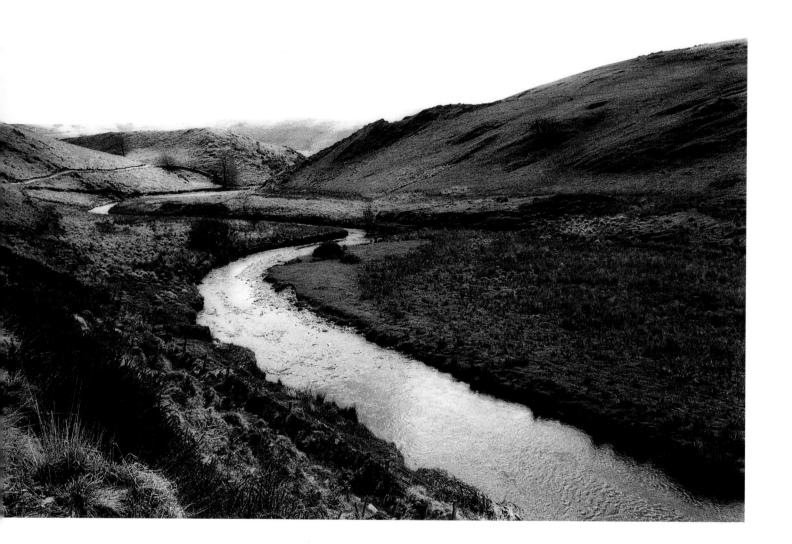

River winding through valley

I wanted to try to photograph this valley before all the mist had burnt off the hills on an early summer's day. The river stood out boldly against the landscape so I used it to lead the eye away from the camera into and through the landscape, as well as to create a sense of balance and harmony.

35mm SLR camera, 28mm lens, green filter

46 Establish a sense of scale

It is not always obvious what the relative scale of a landscape is unless there is something familiar within it that acts as a point of reference: a building, a figure or a tree. Including such an isolated object can have considerable impact, accentuating the vastness of the landscape and providing a point of focus for the picture. It has to be in the landscape though – it's no good placing a figure in the foreground filling half the frame, because this will give no clues as to the scale of the landscape behind.

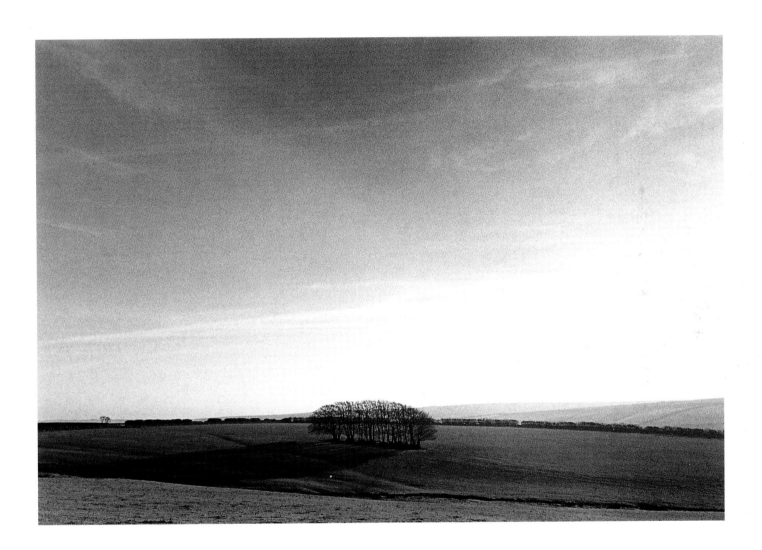

Beech trees in the distance

These beech trees were once part of a hedgerow. Now fully mature trees, the hedgerow has almost disappeared. I wanted to show the openness of the countryside, and the trees and shadows they were casting provided me with the perfect device to provide a sense of scale. Their location, with plenty of foreground visible and space behind, their isolation and their known scale accentuates the wide open countryside.

35mm SLR camera, 28mm lens, green filter

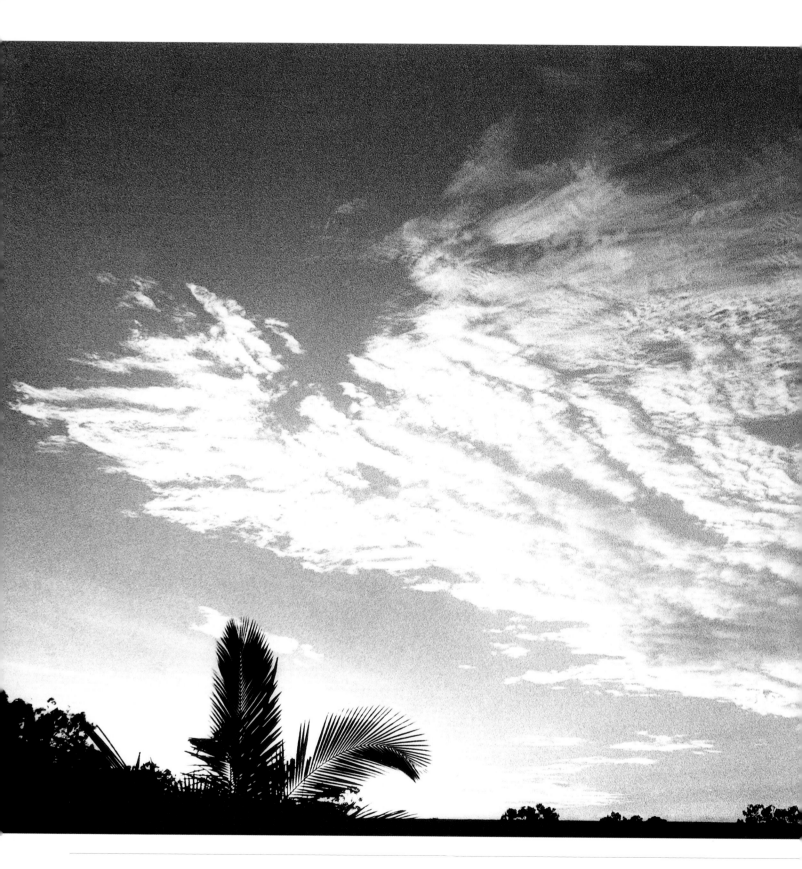

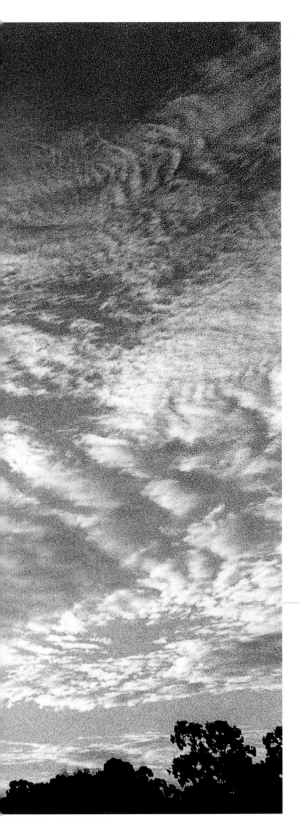

Skies can often be every bit as interesting as the land beneath, and filling the frame with wide expansive sky, with brooding cloud or a gathering storm can be as powerful and dramatic as any landscape. A clear blue sky, or flat overcast days are best avoided however, for obvious reasons. The sky tends to record less densely in black and white than the eye observes, and using filters will give better saturation. A good bet is an orange filter, which will give a richness to the sky while still leaving detail in the land.

Tropical sunset

Australian sunsets can be breathtaking and inspirational. On one such evening I was lucky enough to photograph a beautiful cloud formation and sunset. Returning home the sun was setting and getting more interesting by the minute. Walking up a small hillside to open up the view, I started to look for a composition and decided to include a small section of foreground which was silhouetted against the sky. The sun now below the horizon was lighting the underside of the clouds and making an interesting light. I took one exposure and then had to change films. By the time I had done so, the light was gone.

35mm SLR camera, 28mm lens, orange filter

48 Research your subject

One of the chief attractions of landscape photography is its infinite variety. Leaving aside any changes in the landscape itself or the different lighting throughout the year, the ever-changing lighting conditions that occur in the course of a single day offer such variety and challenge. The down side is how quickly conditions fluctuate: one minute your subject is beautifully lit, the next not; the clouds look interesting for a moment, and almost instantly they are blocking the light or casting shadows across the foreground. However, your goal should be to photograph your landscape in the optimum conditions with the light coming from a direction and at an angle that suits the subject best. You may be lucky and be in the right place at the right time, but you will have a better chance by planning your photographs. If you are out of your own area, a bit of research and planning can go a long way, and if shooting locally, returning regularly to the same locations will soon reveal the best times of day to make your image.

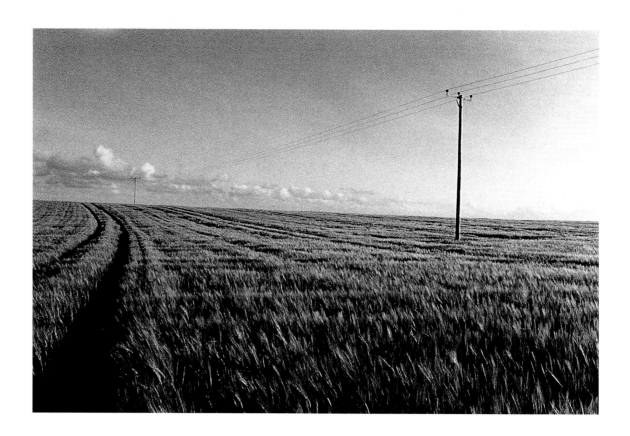

Barley field

This photograph was taken near to where I live in south-west England, on a July evening. Being very familiar with the area, I knew that the barley would soon need to be cut and this particular view would therefore not be available for long. Also I knew that it was not possible to shoot in the early morning because the angle of the sun would have cast light more or less straight into the lens. The light was slightly diffused by low horizon cloud but there was still good definition, and the composition was balanced by the electricity pole, and the track to the left of the image.

35mm SLR camera, 28mm lens, orange filter

49 Crop out the sky

Cropping out the sky can often create a more abstract image, emphasising the shapes, patterns and textures in the landscape without the sky to give it context. It's always worth considering how much the sky will really contribute to the image before including it. Dull featureless skies, which as far as black-and-white photography is concerned can include a clear blue sky, will add little and can even cause problems. (Large areas of pale sky can cause underexposure of the foreground.) You may find there is a much more interesting and dynamic image waiting to be discovered by cropping out the sky.

Field pattern

This land in north Devon is part of an Anglo-Saxon field system which is divided into strips and is the last of its type in the UK. Seeing the newly ploughed rows, my first instinct was to photograph the scene in landscape format, including some of the sky, but I realized that the horizon and sky would pull the eye away from the main subject. Furthermore, cropping the line of the horizon out created a more interesting graphic composition.

35mm SLR camera, 28mm lens, green filter

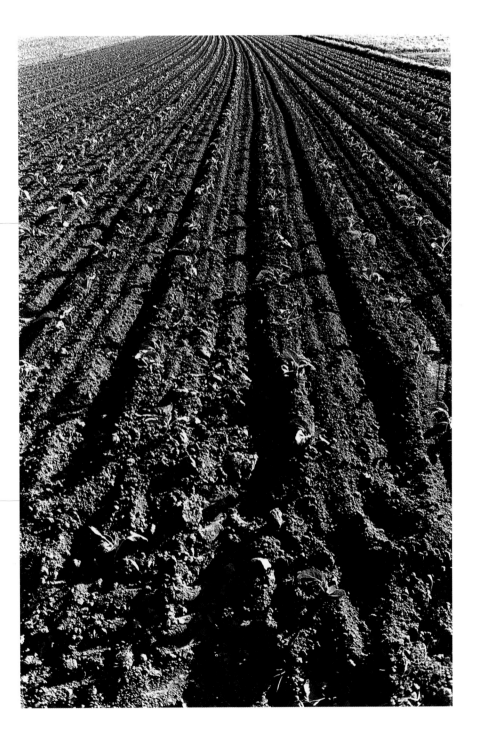

50 Photograph in all weathers

Bad weather tends to drive a lot of photographers indoors but staying out there in all weather will certainly reap its rewards. In bad weather with fleeting light you have to work quickly, but conditions such as rain, mist, fog and snow can produce images with far greater atmosphere than when the weather is benign, and can transform both town and country. Stormy skies offer lots of possibilities, and photographs under these conditions often have great drama. Metering the light in such conditions can be difficult, so bracket if possible – and above all, watch for the constant changes in the weather and be prepared and ready to make the most of whatever it brings.

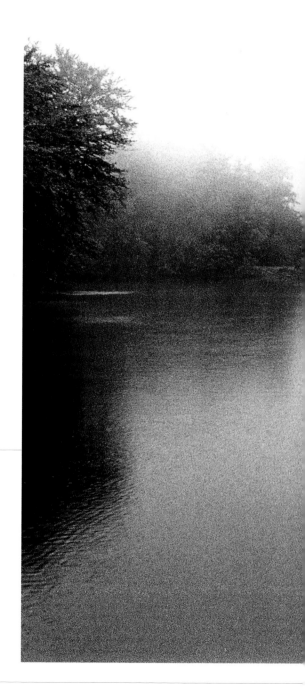

Lake in mist

Near the Ukraine/Slovakia border is a National Park with old beech trees and a freshwater lake. The weather conditions were far from perfect and I almost abandoned the excursion. While I was having a second breakfast to pass time the rain eased and the cloud lifted slightly. Returning to the park area, I started to walk around the lake following the footpath and decided that the rain and mist might contribute to a very atmospheric image. I set up with a tripod, and took a TTL spot-meter reading of the water and the forest in the far distance, which I wanted to make sure would record as a murky mid-tone.

35mm SLR camera, 28mm lens, orange filter

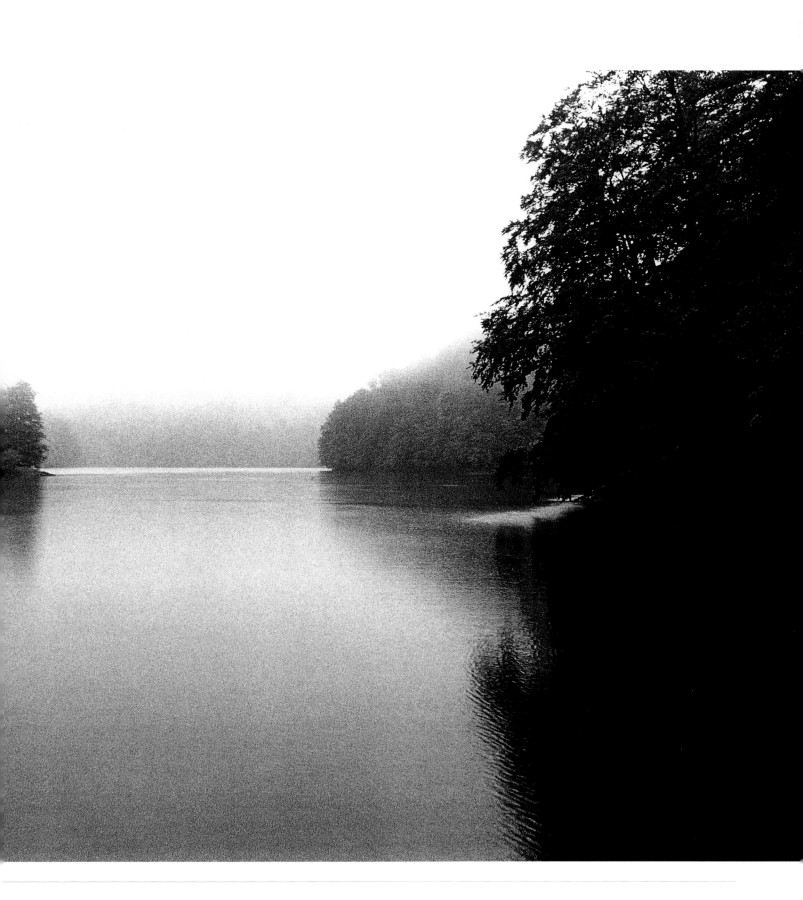

51 Photograph trees

I believe trees are the most expressive elements in the landscape. Their shape and form is iconic. Amongst the first things a child draws, a tree is one of the basic visual building blocks that go to make up our understanding of the world. Trees make wonderful subjects for photography because they are individually beautiful and infinitely variable. Photographing one species in its many guises could be a worthwhile project but the variety offered by all different types provides potential for a lifetime of photography – from deciduous woodland to equatorial rainforest, from single trees to groups, lines, copses or woods, from the bare skeletons of winter to the abundant canopies of summer.

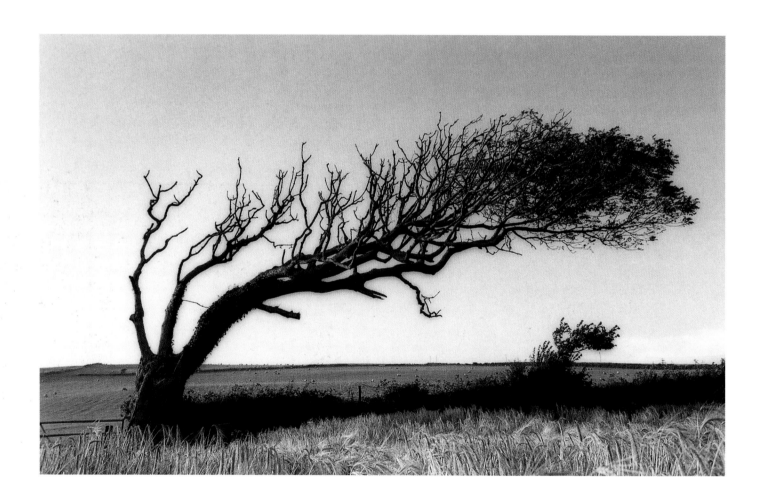

Windswept tree

In the coastal regions of England, windswept trees are a feature of the landscape and a great subject to cover. This is a favourite tree of mine, quite near to where I live. I chose to photograph it in the late afternoon to get the side lighting and a long deep shadow cast by the tree, but before the quality of light started to change as sunset approached. I particularly like the young tree growing up in the shadow of its canopy.

35mm SLR camera, 28mm lens, orange filter

52 Keep the horizon level

This is a simple but crucial point in landscape photography. There is nothing more unsettling than a wonky horizon, especially if it's a seascape with the sea running downhill. And if you want to present your photographs full frame, as I do, you need to get it right as there will be no opportunity for cropping later. Keep the horizon as level as possible; some viewfinders have markers to help as indicators for making a straight horizon and your chances will certainly be improved if you use a tripod; some even have a built-in spirit level.

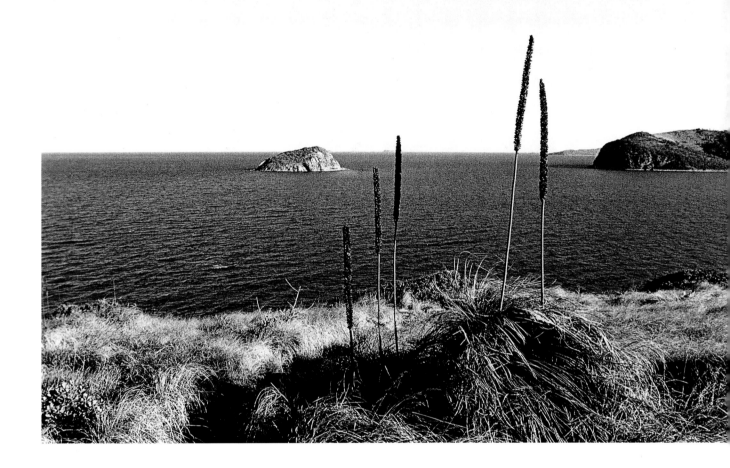

Coastal view

The Queensland coastline of Australia seems to roll on forever, with long beaches punctuated by prominent headlands. I walked through some bushland which brought me out at the top of a headland and this view opened up. I aimed to keep both the small island in the distance and the foliage in the foreground in focus, and also included part of the distant headlands. The early evening light allowed me to use a fast shutter speed and keep good depth of field; I was hand-holding the camera so a lot of my concentration was focused on making sure the horizon was level, and that I didn't ruin the image through careless framing.

35mm SLR camera, 28mm lens, green filter

53 Photograph an empty beach

A wide open beach is at once the easiest and most difficult subject to photograph. Easy because it is a familiar subject usually with ready access, making it possible to visit and photograph it all year round, and generally there are no extreme technical difficulties to overcome. Difficult because the open expanses seem to have no immediate points of focus, and precise technique is required for a quality image. But look closely and beaches offer tremendous opportunities for the photographer, with the patterns in the sand, reflections off the sea and tidal pools, broad sweeps of the line of the beach or the sea, and of course it's never really empty: a bird or a boat or a piece of driftwood will often provide a point of focus within the wider landscape.

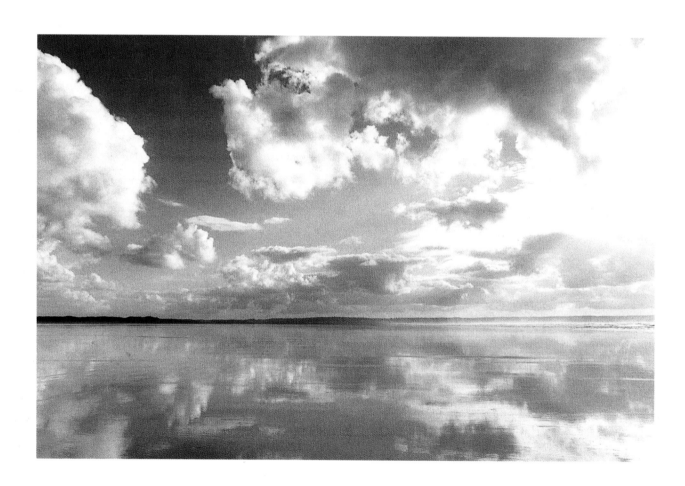

Beach

There was cumulus cloud overhead and sunshine breaking through the gaps as I walked along Saunton beach, Devon, on a warm October day. The tide was dropping back to the low-water mark and it had left pools of surface water on the sand all along the beach. Reflections from the clouds formed on the wet sand and a slight mist hung over the water's edge. I wanted to show a big sky in order to emphasize the reflections on the beach; with this in mind I found an uncluttered foreground so I could concentrate on the reflections and shoot a clean, airy and spacious photograph.

35mm SLR camera, 28mm lens, yellow filter

54 Look for reflections

Often ignored by our conscious minds, reflections are of great importance to the photographer. Reflections offer a chance to look beyond a structure or form, and instead to look into the mirror of it. A quiet, literally reflective, mood is often the result, stressing tranquillity and calm. The quality of the reflection will depend on the quality of the light and stillness of the air, but primarily on the stillness of the reflecting surface. There is often a marked difference in brightness between a reflection and its source, the sky for example is often very much brighter than its reflection so careful metering is important, or use a filter to reduce contrast.

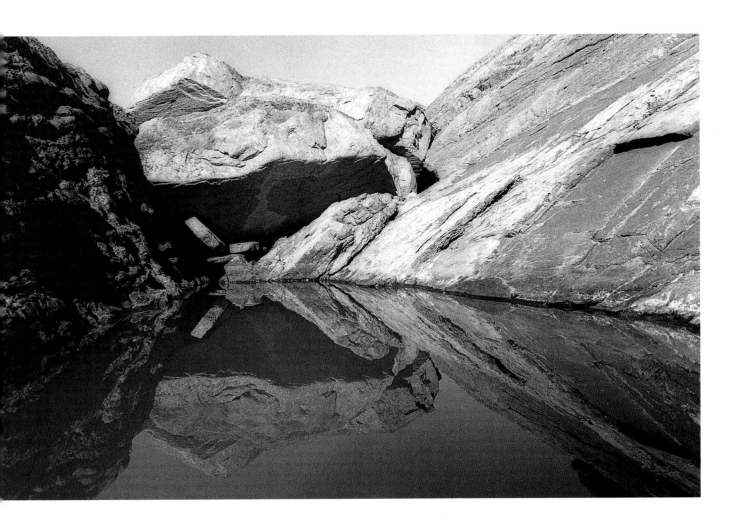

Rock pool

Scrambling over a low tide area of bedrock stretching out along a headland, I found this rock pool in amongst the formations at the cliff base. It was a hot and still September morning, and seeing the reflection in the water, I was quite sure it would make an interesting subject. Looking for a decent vantage point I got down close to the surface of the water.

With the light sharp and the subject in full sunlight, I used a yellow filter for contrast control and spot metered from various sections of the image in order to determine the exposure. I also bracketed my exposures for safety.

35mm SLR camera, 28mm lens, yellow filter

Landscape

Capture the movement of the sea

From great swells and dramatic breakers to tranquil waters, the sea is never still for a moment and as such is a constant source of inspiration. You can capture the movement of the sea in different ways depending on the shutter speed selected. A very slow shutter speed will create a smooth mist and give an ethereal quality to the water. At the other end of the spectrum a fast speed will freeze any movement, and taken to extremes, 1/1000 sec can create unnatural or even surreal results. A shutter speed of 1/125 sec will give a more natural effect allowing some movement, but not so much as to erase the detail. It's often best to photograph the sea when the weather is overcast because the reflective qualities of water can make high contrast a problem in bright sunlight.

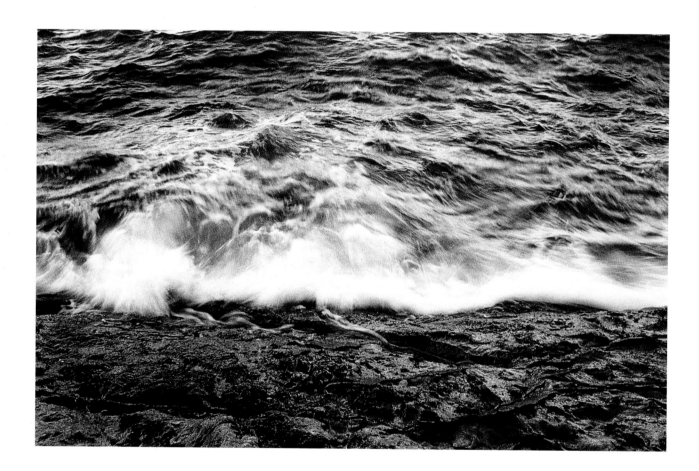

Sea movement

Working my way around a cliff headland at high tide with the sea snapping at my feet was a great way to spend an afternoon. Watching the movement of the sea surge over the rock and recede back again, it created interesting shapes and was never the same twice. Taking up a low vantage point, I then watched several surges of water and noted the variations of shape and form with each subsequent wave. Having composed the shot, I released the shutter the moment the white water appeared, using a shutter speed of 1/30 sec to keep just enough movement to show the crashing white water.

35mm SLR camera, 28mm lens, green filter

56 Find a high viewpoint

A high viewpoint may seem basic to landscape photography but it is no less important for that. The higher you are able to get, the further you are likely to be able to see, and the more likely you are to find a grand landscape beneath you. This obviously applies to traditional beauty spots and viewing points which occupy commanding spots in the landscape looking out over miles of countryside. However, even raising your camera a few extra feet in the air on a stepladder or platform can make a significant difference, changing the angles and helping to get foreground detail into a composition.

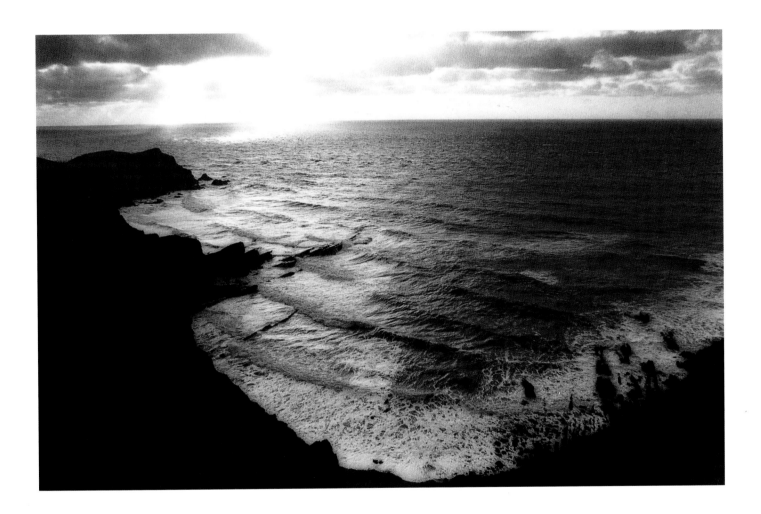

Winter beach

Taking a winter stroll over cliffs, the atmosphere was clear but the light was problematic with lots of cloud and splashes of sunlight occasionally breaking through. I had to work quickly knowing I would lose the light if I hung about. I took a meter reading from the sea area, letting the cliffs remain dark, just showing their craggy outlines below. Low shafts of light were shining through the clouds, but keeping the sun behind me helped to avoid problems with flare. Careful to keep the horizon level, I made a series of exposures.

35mm SLR camera, 28mm lens, red filter

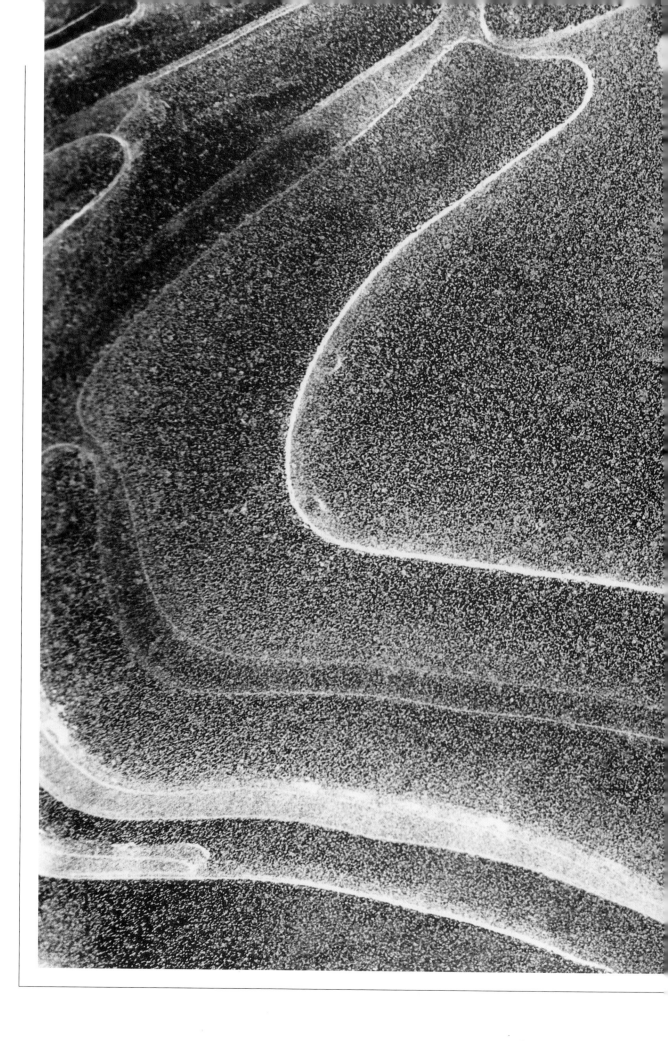

Abstracts and Still Life

57 Photograph everyday objects

We are all surrounded by objects that we take for granted – but look again and you will find a lifetime's supply of subjects for still-life photography. The transforming power of black-and-white photography can make a study out of almost anything, and the close scrutiny of the camera will reveal previously unconsidered beauty in a line or angle or the chance fall of a shadow. You also have complete control over your subject and your environment and can play with the lighting and tonality of the final image at leisure, perhaps making sequences of images of the same subject treated in different ways. Some of the most famous images in the history of photography are still-life studies, so look around you and photograph everyday objects.

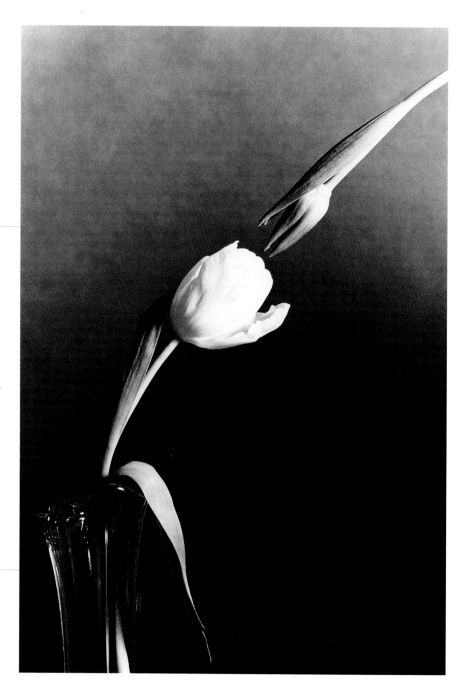

Two tulips

For this tulip study I set up a plain paper background and used a single 200-watt tungsten lamp as the light source. The composition is all about the relationship between the two tulips, almost – but not quite – touching: I set up a stand with an extension arm to hold the second tulip in position. I then blocked off some of the light falling on the background and also added shadow to the lower part of the image so that the shape of the vase was clearly picked out in the highlights on the glass. Using a 135mm lens allowed me to get in tight and fill the frame from a comfortable distance.

35mm SLR camera, 135mm lens, yellow filter

58 Record decay

Life and death are often symbolically present in still-life paintings as a skull or decaying plants. The ravages of time and the elements can produce fascinating and unexpected subjects of anything from rotted wood in the garden to a bunch of flowers left to die in a vase. Charting the progress of a flower or fruit from fresh, colourful vibrancy through to its withered and decomposed state throws up endlessly fascinating textures and colours, and can also work well as a series. Decay and the process of decay makes a powerful subject for still-life photography, so look out for suitable subjects in nature and photograph them *in situ*, or bring interesting objects into the studio to construct a more deliberate still life. You could photograph something fresh and chart its decay over a period of weeks or months.

Sheep's skull

I found this sheep's skull whilst out walking on moorland and left it for a few months, letting it weather and bleach before bringing it into the studio to photograph. Using a table top and just window light, I set up a canvas to serve as the background and foreground on which the skull sits. I used a small piece of white card as a reflector to the left of the image to lighten the shadow areas and help keep the tone of the skull even, and I also blocked off some of the light falling on the background, allowing this area to remain dark.

35mm SLR camera, 135mm lens, yellow filter

59 Photograph silhouettes

One of the advantages of black-and-white photography is that you can pare down an image to its most fundamental shape and structure. Photographing subjects in silhouette is an effective way of doing this. These are created by back-lighting and a degree of care is needed when shooting them. The light usually creates a halo around the edges while the front of the subject will be very dark. The camera metering system will indicate less exposure is needed if too much of the silhouette is filling the frame, so be prepared to close down a few stops to compensate for the brightness of the backlight or take a reading from the brighter areas outside. You'll get best results from taking a spot reading separately from the silhouette and the background and judge the exposure from this. Beware of direct sunlight falling on to the lens, causing flare. A lens hood may not always shield the whole lens so use your hand or a piece of card to offer more shade.

Family statue

I came across this statue in Prague in the Czech Republic, a remnant of the Soviet regime. The ideal-ized family are meant to represent an archetype, and so creating an image which reduces them to their most basic visual form seemed appropriate. I settled on a straightforward view, looking up to emphasize the monumentality, cropping out the pedestal of the statue to balance the composition. As it was an overcast day the light was relatively simple to read. I took a meter reading of the sky, which was pale grey, and I opened up one and a half stops so it would record as pure white. The figures themselves were almost black with dirt so I knew they would record that way.

35mm SLR camera, 28mm lens, orange filter

60 Isolate the subject

It is rarely possible in reality to isolate an element of the landscape so completely that we can experience it as a single entity. In the real world things interact and interrelate and it is hard to ignore context and environment. But as photographers we have control over these distractions and can choose to isolate a single element. In a more abstract image this will place emphasis on the graphic design of the photograph, but a more figurative approach to an isolated subject will encourage the viewer to observe it more closely than they ever would in the real world. Such an approach can throw the spotlight on subjects that would be routinely overlooked.

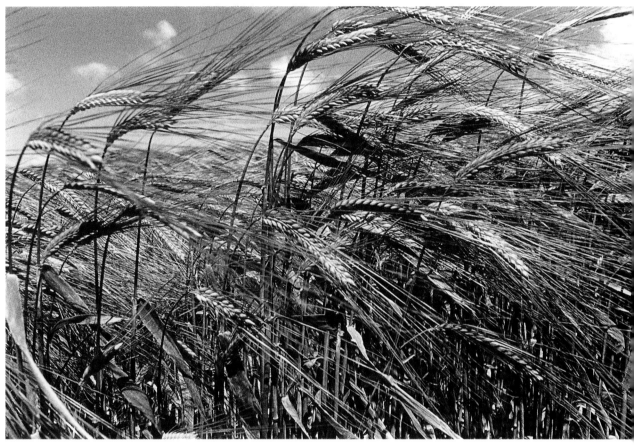

Barley

I wanted to make this image not of a field of barley or the landscape containing a field of barley, but of the crop itself. I wanted to examine it and get a sense of being in amongst the barley as it gently swayed to and fro in the breeze. Crouching down low, I set a fast shutter speed, focused on the immediate foreground and watched the movement until I felt the decisive moment – and shot.

35mm SLR camera, 28mm lens, yellow filter

61 Be precise

When you photograph nature and place emphasis on the inherent patterns, shapes and textures, the resulting image becomes more about the graphic content and less about the original subject. The image is less representational of the subject as it exists in reality and more about the line and form of the two-dimensional image recorded as a photograph. It therefore becomes very important to arrange the elements in your frame with minute attention. Watch for every line and shadow in the subject, and be aware of how it will record in the final image. An unconsidered line or shadow might well become a dominant graphic feature once the crop has reduced the image to an almost abstract design.

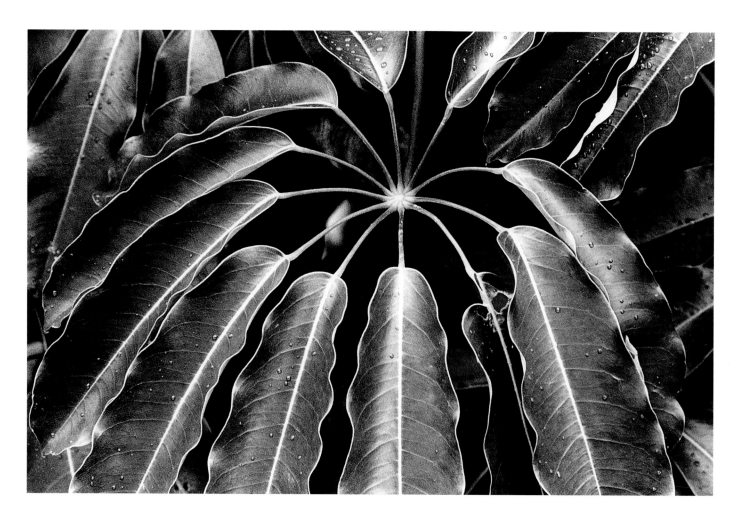

Umbrella tree leaves

I found this umbrella tree in an Australian rainforest and had already photographed the whole tree when I noticed this arrangement of leaves and decided to make a detail shot. Cropping out all context, careful placement within the frame was of paramount importance.

I set up a tripod and, using a long lens to get in tight and fill the frame, composed and recomposed until I felt all the shapes and lines sat in the frame to my satisfaction.

35mm SLR camera, 200mm lens, orange filter

62 Photograph natural forms

The term 'still life' makes most of us think of an Old Masters painting featuring an arrangement of flowers, fruit or other items on a table. But it can be an arrangement of any inanimate object or objects in any circumstance and it doesn't have to be an arrangement that has been engineered for the purpose. Nature is the greatest source of inspiration for all types of photography and isolating natural forms and carefully arranging them in the picture frame has endless possibilities for creating still lifes. Boulders on a beach, fallen leaves, driftwood – the opportunities are all around us and easily available, a trip to the beach can provide a wealth of material.

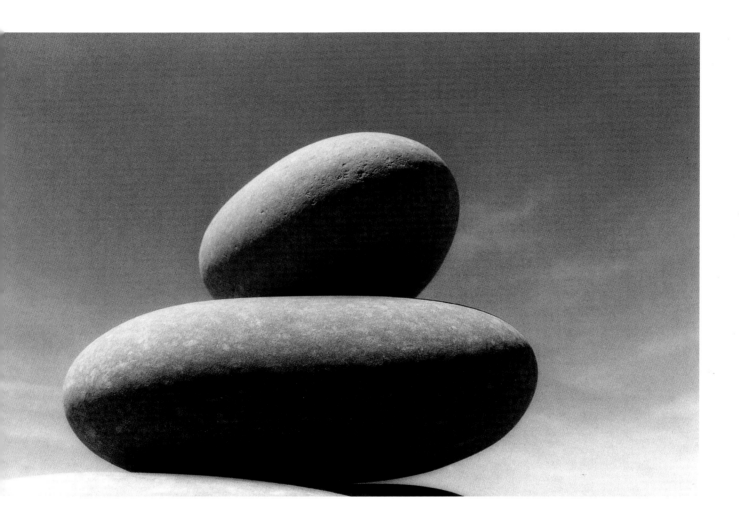

Boulders

This Devon beach was packed with interesting shaped stones and I picked these two out to arrange for my photograph. Placing the larger on a natural platform, I set the smaller one on top and experimented for some time to get an arrangement I liked (without the top one falling off). Setting up a tripod and using a standard lens, I metered carefully, establishing the brightness range between the deep shadows and bright highlights on the rocks, because it was important to retain detail throughout all areas of the image.

35mm SLR camera, 50mm lens, orange filter

91

63 Use window light

It's natural enough when photographing indoors to reach for the flash, but this is often not the best solution as the light can be harsh and hard to control. Natural window light on the other hand lends itself perfectly to still-life subjects as it gives consistent and often soft, diffused light. If light levels are a little low, the deliberate nature of setting up still-life compositions and the fact that your subject is not going to move should mean you have plenty of time to set up your tripod, and your shutter speed will not be restricted. On a bright sunny day you can cover the window with a sheet of tracing paper to soften the light, and white cards will do a good job as reflectors, bouncing light back into the shadow areas from the other side.

Beach still life

Before constructing this still life I set up a table slightly above the level of the window-sill, on the side of the house that is usually in shadow so the light would be naturally soft, but being a bright day, light enough. I set my camera up on a tripod and framed the area I was intending to photograph and only then began to place the stones, shells and other objects. I placed two pieces of white card to the left of the image; these reflected light back into the shadow area around the large boulder, and evened out the light on the left side. Keeping plenty of depth of field I shot a series of exposures with a slow shutter speed, bracketing plus and minus one stop.

35mm SLR camera, 135mm lens, orange filter

64 Look for surface texture

Black-and-white film can record surface texture with great accuracy and the play of light on interesting surfaces can make for fascinating subjects. You can affect how texture will record by choosing faster film so the grain mixes with the surface texture, or finer film to record the subject very accurately. Lighting of course plays a crucial part in revealing texture: direct low light will reveal the modelling in a surface texture most effectively, with high contrast showing up the contours in deep shadow; however, for detail the softer light of an overcast day will be more effective.

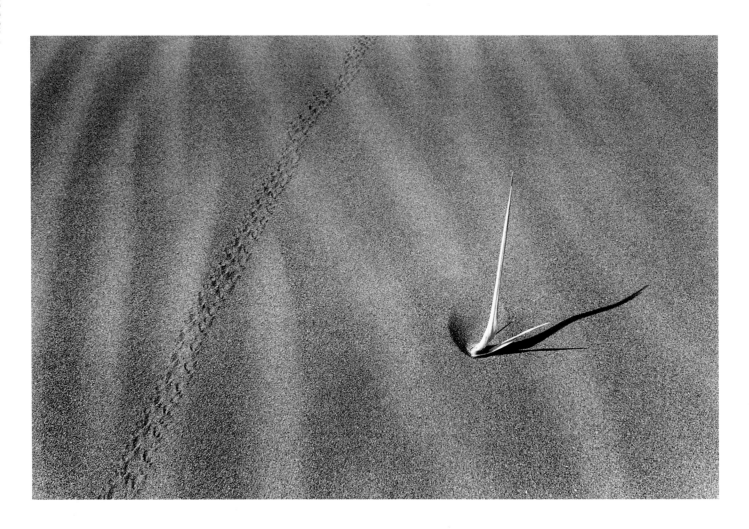

Sand track and solitary plant

I was attracted to the texture of the sand and the pattern of this animal track next to a solitary plant, and was careful not to disturb the sand around it as I selected my viewpoint. I chose a green filter, as I wanted soft detail in the shadow area. This would also help render the sand smooth compared to the effect of an orange filter. The animal track passes diagonally across the lines of the sand and is balanced by the plant, allowing the texture to be the dominant element in the image.

35mm SLR camera, 50mm lens, green filter

65 Look under your feet

As well as looking around, don't forget to look directly down. The ground beneath your feet can be a rich source of photographic subjects, as the variety of patterns, textures and structures is enormous. It's best to use a standard or short telephoto lens for this type of relatively close-up photography, as a wide-angle lens will start to distort the perspective at the edges of the image. Fascinating and beautiful patterns and textures are everywhere – in sand, mud, grass or rock – but I find that interest is more likely to be sustained in an image if another element is featured.

Two shells

Crossing a beach at low tide can reveal much to photograph: patterns in the sand, shells, seaweed, driftwood and other flotsam and jetsam, all add to the character of the beach. I came across these two shells, both of which had left a similar pattern in the receding tide and the shape reminded me of two fish. I balanced the shells evenly from the bottom of the frame and equally from the sides and allowed enough space for the fish shape pattern to emerge. Spot metering the shells and the sand, I used a standard lens and yellow filter in order to control the contrast.

35mm SLR camera, 50mm lens, yellow filter

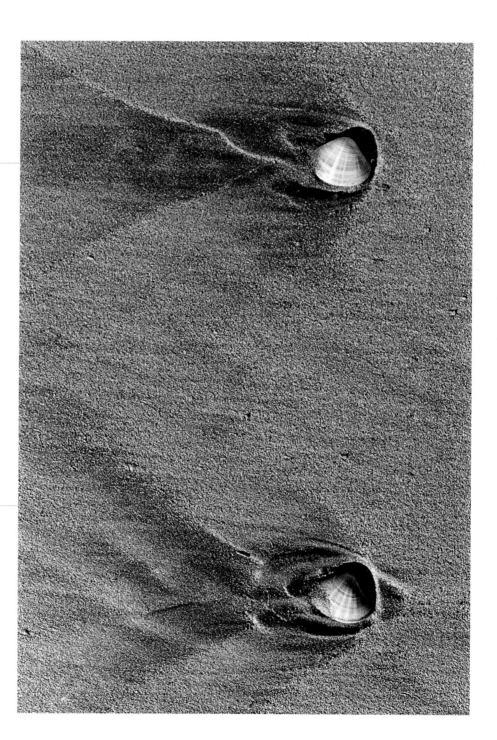

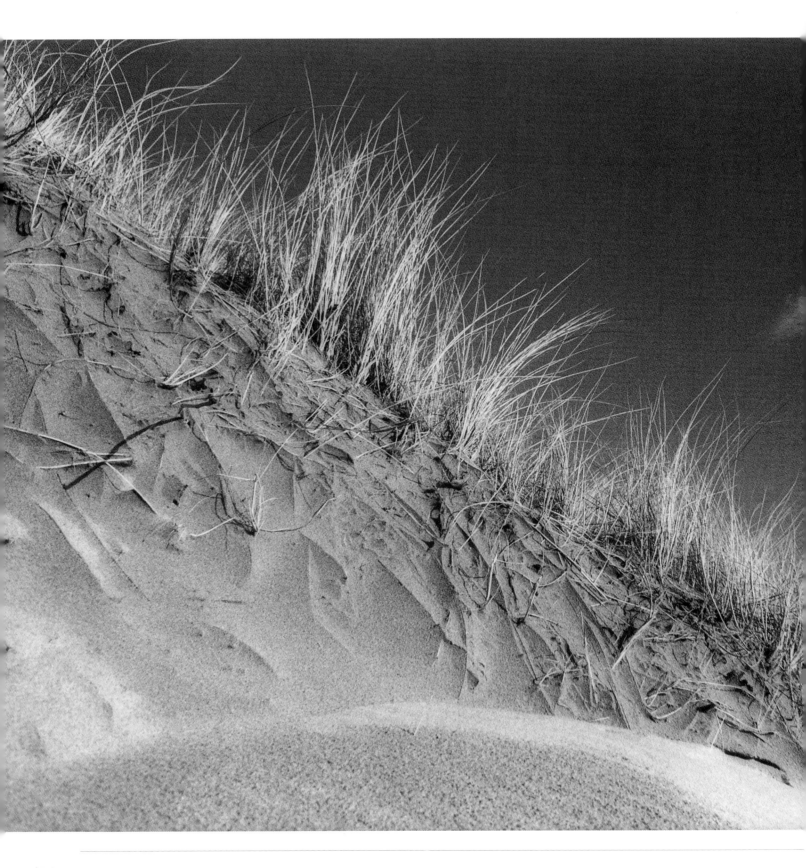

66 Use nature's patterns

We've all watched the clouds rolling by and fancied that we could see the shapes of ships or animals or faces. Such coincidences of form appear everywhere in nature and with a camera you can frame a subject just as you like; there are witty and amusing compositions to be found all around. Like an optical game, your picture may only appear from a particular angle and a specific distance – the moment you move a few degrees it will disappear again. But take advantage of happy coincidences in nature – ambiguous shapes and textures, and strange juxtapositions – and use them to have great fun with your photography.

Marram grass and cloud

When I saw this section of a sand dune it immediately reminded me of a breaking wave, and the straggly marram grass along the top looked like the white water or feathering on top of the wave as if it were just about to break. A single cloud was passing, and I waited for it to move into place to balance the sky section of the photograph.

35mm camera, 28mm lens, orange filter

Abstracts and Still Life

Photograph driftwood

Driftwood can be found in many shapes, sizes and textures, from small twigs and planks or pallets of wood through to enormous tree trunks, on any beach. The wood becomes smoothed and worn by the sea the longer it has been drifting and as it lies beached, the sun dries and bleaches it and the smoothed wood splits and cracks into new and interesting shapes. These extraordinary objects provide fascinating shapes worthy of close scrutiny and photographic study in themselves, but the process of transformation from trees to (often) man-made objects to the smoothed, cracked or gnarled shapes found on the beach provides a depth that makes it endlessly fascinating for photography. Driftwood is a versatile subject and can be used to form many styles of composition.

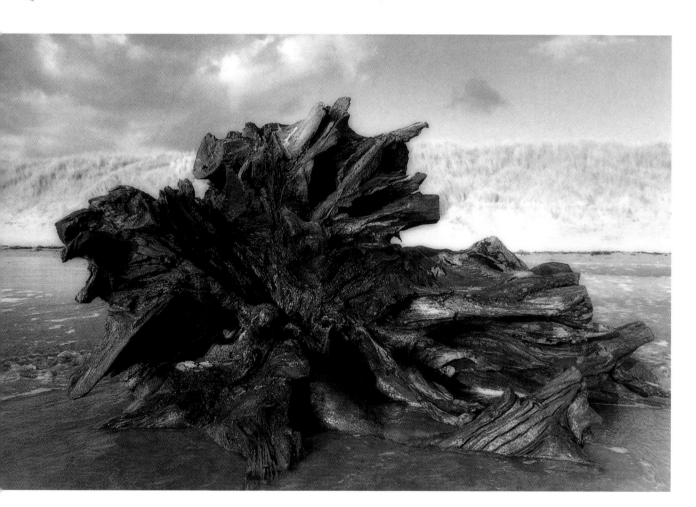

Driftwood

Walking the length of a beach at high tide I came across this tree. It had been in and out of the water for some time but the lower segment was still water-logged while the sun had dried out much of the top section. The left side of the driftwood looked like an animal's head and I made this the point of focus.

35mm SLR camera, 28mm lens, green filter

68 Photograph rock formations

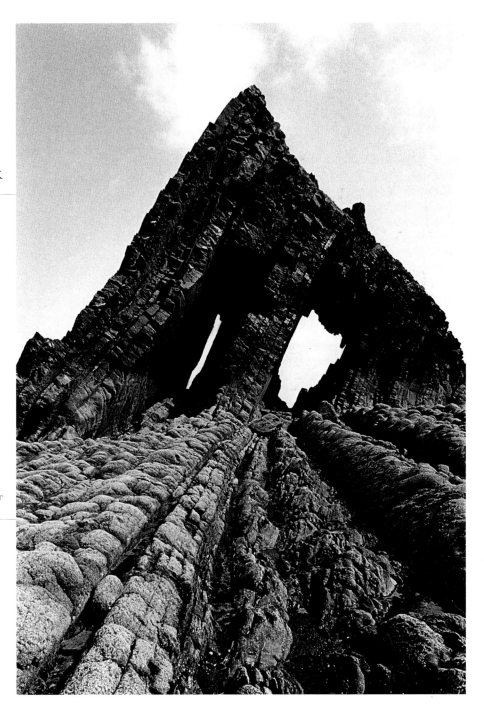

To my mind, cliffs and rock formations give a place a sort of pre-historic feel – knowing that they were created millions of years ago, compressed and formed by tremendous forces and later exposed, sculpted by erosion and glaciation. All those years are literally stored in the layers of rock and fossil. Of course you cannot photograph atmosphere, but the many wonderful shapes and formations of rock provide a great subject for the photographer. Look for cliffs or faults where layers of rock have been exposed, or textures and shapes within a rock surface.

Blackchurch Rock

I searched out Blackchurch Rock in Devon, England, because I was intrigued by the name and hoped that it would live up to it. It can only be reached at low tide so I had to time my visit. I settled on this portrait composition, using the bedrock to take your eye up to the pyramidal rock. Taking meter readings from the foreground, the rock structure itself and the sky, I opened up half a stop on the average reading to retain detail in the rock formation and allowed plenty of depth of field to keep sharp focus from the close foreground right through to the back of the image.

35mm camera, 28mm lens, yellow filter

Architecture

Architecture

69 Look for unusual lines in modern architecture

It is difficult to truly represent the architecture of a building in a single photograph by trying to describe or record its shape. Better for the creative photographer to use the many opportunities the architect has provided to express the atmosphere of a building and create interesting images from parts, angles and views of the building that will often be missed by the visitor in person. Architecture by its nature gives you a subject with interesting lines and angles. The important thing to remember, as a photographer, is that you are ultimately creating two-dimensional images, so arrange the shapes and angles to fit your frame and use the lines provided by the building as a starting point in your own two-dimensional image.

Cinema

The circular construction of London's IMAX Cinema allowed me to create a shape with an unusual smooth symmetrical curve. The exaggerated perspective of the wide-angle lens and the converging verticals created by the tilt of the camera all contribute to the monumentality of the building and the compositional effect. Using the TTL spot meter I took readings of the building and sky so that I could calculate my settings, and an orange filter darkened the sky and helped control contrast.

35mm SLR camera, 28mm lens, orange filter

70 Look for texture in buildings

Buildings are fixed and formal subjects and as such are suited to a deliberate approach. Allow time to study a building; look for structural and decorative details that might make a good photograph. Time will quickly make its mark and the signs of weathering, decay or vegetation growing on buildings can make for great photographs. Even modern buildings can quickly show dirt and water staining; and the texture of ageing and worn wood, brick or stonework adds a wonderful patina to a building. All these make good subjects for the play of light and tone in black-and-white photography. Side-lighting will reveal shadows most strongly, or shoot on an overcast day when the light is even and the contrast controllable for a full tonal range.

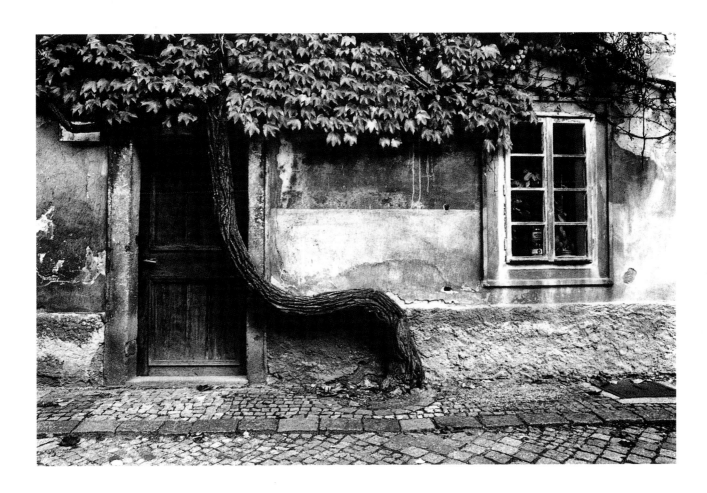

Bent tree and doorway

While visiting the castle area in the city of Prague, I came across a monastery courtyard, and this wonderful tree growing across the doorway caught my eye straightaway. The unusual shape of the tree makes a natural subject but I was particularly attracted to the different textures and tones of the wall, the cobbles, the foliage and the wooden door. The light was even and overcast and therefore good for recording detail, with no hard shadows and uncontrollable contrast. I included the window frame in the composition to balance the door and took an average meter reading of the whole scene, which was quite evenly illuminated.

35mm SLR camera, 28mm lens, green filter

71| Manipulate the scale

Active framing of any subject can give depth and meaning to a picture and this is certainly true with architectural subjects. Manipulating the relative scales and importance of buildings by how you choose to frame them can be a very powerful tool. It is possible to make a gravestone tower over a church, or a man dwarf a tall building. The obvious techniques are to shoot from low down placing your main subject in the foreground, but using a wide-angle lens you can accentuate the effect with exaggerated close foreground and dramatically receding background. Leaning verticals will be more pronounced and you can use this dramatic effect to your advantage.

Tower block and church

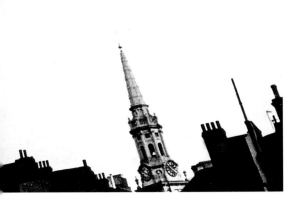

The Centrepoint tower in London was looking surprisingly gleaming one day in the very weak winter sunlight which muted any hard shadows and illuminated the building evenly. Initially I made an image in portrait format isolating the building within my frame. But turning the camera back I noticed the steeple of St Martin-in-the-Fields church in the corner of the viewfinder and felt the inclusion of the older building made for a much more interesting picture. The modern uncompromising architecture of Centrepoint dwarfs the older building in the image, but is also in some way dependent on it. This seemed fitting, as with all buildings in the centre of London, the old have to jostle for space with the new.

35mm SLR, 28mm lens, yellow filter

72 Use a frame within a frame

Including a framing device within an image can be an effective means to give your images impact. Architectural subjects are particularly useful for this, often allowing you to use a window, gate, arch or doorway as a frame for whatever is beyond, whether it be another building or not. The natural frame focuses attention on the subject, helps with the sense of perspective and three-dimensionality, and gives an image a pleasing sense of balance and harmony. Of course, frames don't have to be perfect man-made rectangles, and the same effect can be successfully achieved with foliage in the foreground or an overhanging branch. It can be a useful trick on dull days when you want to crop out an uninteresting sky. You need to keep focus from front to back of the image and so will have to select a small aperture unless you want to let your frame blur.

Shutters within shutters

The seventeenth-century Governor's Residence in Havana, Cuba is a building of four storeys with archways and balconies and a square courtyard which now accomodates a café and restaurant. I asked if I could look over the house and went exploring around the balcony levels. The arches and shuttered windows automatically created a sense of balance and harmony, and gave me the shot I was after. I wanted to keep the shutters sharp so I focused on them and metered on the sunlit wall opposite to establish the brightest area of the scene, which I wanted to record as white.

35mm SLR camera, 28mm lens, green filter

73 Photograph details

Architecture

When taking a series of photographs of a building, shots of architectural details such as doors, windows, sundials or carved statues can be very effective as a supplement to the general view. Even a relatively insignificant detail, which in the context of the building may not seem much, can make a great photograph and can include a great deal of information about the architecture. Move in close to embellishments, handles, knockers or locks, sculptures or painted decorations. A long-focus lens is sometimes necessary to fill the frame from a distance as it will often not be possible to get close to the subject.

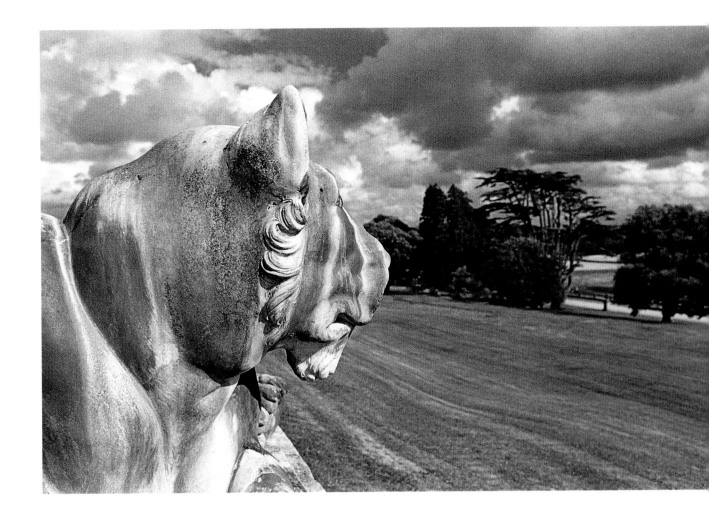

Lioness statue

Visiting a country house in the West of England, the light was cloudy but bright with the sun occasionally breaking through. As the sun got lower the light improved and beautifully illuminated the textures of this statue. I wanted to follow the statue's gaze into the distance and composed the shot allowing space for the lioness to look into. To best reveal texture and so as to dramatize the sky, I used a red filter. A tripod helped me keep precise control over the composition.

35mm SLR camera, 50mm lens, red filter

107

74 See it straight on

Although every child will choose to draw a house straight on from the front, in the grown-up world, the least expected way to photograph a building is square on to it. One's natural inclination is to find an angle to give a balanced perspective and to give an impression of a building's three-dimensional design. But as photographers we work in two dimensions and to use the regular forms of buildings straight on can give you interesting symmetrical designs and large graphic compositional blocks to play with. There is also a simple direct honesty about photographing buildings in this way. A tripod will be useful to frame accurately and to keep the camera parallel to the subject so as to avoid the verticals falling in.

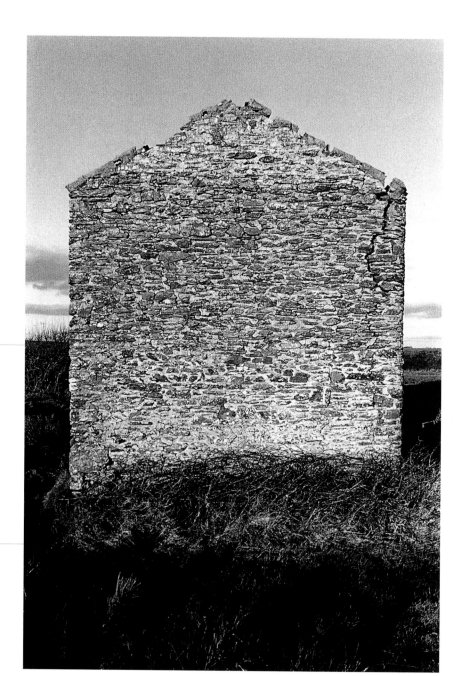

End of barn

There are a number of old barns like this near where I live in Devon. Most of them are about two hundred and fifty years old. This is a very simple building, built to serve a simple function. It seemed fitting therefore to photograph it in this straightforward way.

35mm SLR Camera, 28mm lens, green filter

75 Photograph interiors

The word 'architecture' conjures up for most people the idea of classical arches, gothic churches or modern constructions of glass or steel, but always their external appearance. But great buildings are almost always as impressive inside as out, and sometimes much less impressive exteriors can contain spectacular interiors, so don't neglect the opportunities of photographing inside. Lighting can sometimes be difficult in large enclosed spaces and setting up a tripod may not be allowed, but even if you are defeated by this problem, there will always be interesting details on a smaller scale to turn your attention to. Anything from a carved column to the angle between a steel cable and a pane of glass can make a fascinating subject to photograph.

Thermal baths

The thermal baths are famous in Budapest, Hungary and this spectacular building offered a great chance for photography as it is so beautifully lit from the spectacular glass-vaulted ceiling. I made my way up to the balcony to get a good view of the whole interior space and used a wide-angle lens to get as much of the vaulting into the frame as possible. I improvised a tripod by simply resting my camera on the balcony rail, took an average meter reading, and focused on infinity.

35mm SLR camera, 28mm lens, yellow filter

76 Shoot buildings from above

Most architecture is shot from ground level, and indeed we mostly experience architecture from the ground, for obvious reasons. Finding a high vantage point so that you can shoot down on buildings opens up a whole new perspective, allowing you to see buildings in context and how they fit together in the wider environment. It also solves some of the perennial problems of photographing buildings such as the converging verticals caused by having to angle the camera upwards, and the difficulty of lighting when neighbouring buildings are casting shadows across. You can treat a cityscape from a high viewpoint very much as you would a landscape, using a wide-angle lens and plenty of depth of field. Watch out for reflections in glass buildings, though: either move to make the most of them, or control them with a polarizing filter.

Rooftops

Prague's steeples and domes make a magnificent subject and my perch on a tower gave me an unbroken 360-degree view. For my composition, I decided to use the dome as the focal point, placing it in the foreground to the left of centre and keeping the horizon above the centre line of the image to accentuate the impression of looking down on a great sweep of rooftops. Taking an average light-meter reading of the whole scene, I also took a spot-meter reading of the dome so that I could make sure I retained detail in this brightest area.

35mm SLR camera, 28mm lens, orange filter

77 Use a building's own light

Whether it is the lights in an office building or a spot lit castle or cathedral, buildings illuminated with their own light can provide interesting photographic opportunities. Keep an eye on whether the light is even; often you will find that the areas directly hit by the lights are considerably brighter than others, and shadows will be very deep, so try to exclude large areas of extreme shadow. A fast film will help keep faster shutter speeds in lower light conditions, and of course a tripod will be useful in most circumstances. When taking a light-meter reading, avoid the lights themselves or you will end up with underexposed negatives; instead take a reading from the most evenly lit area you can find.

Football stadium

After a game at this UK football stadium, the ground emptied quickly and gave me the chance to make this shot of the empty arena, lit by the floodlights. I liked the view through the goal net and carefully arranged a symmetrical composition. I metered from the turf area, excluding the floodlighting, and used a slow shutter speed to obtain good depth of field. Not having taken my tripod to the game I had to hand-hold the camera and concentrate on controlling my breathing to stay steady enough to use a shutter speed of 1/8 sec.

35mm SLR camera, 28mm lens, yellow filter

78 Photograph gardens

Architectural photography concerns the depiction of buildings, but often the architecture will spill beyond the four walls and into organized gardens, with walls, paths, fountains, bridges, statues and other details which have more in common with architecture than with nature. The mixing of formal and natural elements, the organic forms intermingling with clean architectural lines and the constantly changing relationship between the two throughout the year, make this a rich subject matter for photography. From historic houses to private homes, there are many gardens that are open to the public, although it's not always possible to shoot when the light is best. So do your research and choose the right time of day and year to maximize your chances of getting good light when the garden is open to visitors.

Garden pond

I came across this pond in an enclosed part of a beautiful formal garden in England. The light was good and clear for the time of day which was mid-afternoon and I decided upon a symmetrical composition, placing the statue slightly above the centre of the image. Using a tripod, a red filter and a polarizing filter, I was able to control the amount of reflection from the pond, and determined the depth of field by using a slow shutter speed which allowed me to stop down to f/16.

35mm SLR camera, 28mm lens, Kodak polarizing filter and red filter

79 Mix the styles

Architecture is rarely allowed to exist completely in its own space – it's usually impossible not to see it in the context of the things around it, particularly other buildings. Isolating a building from its environment can make for a striking and monumental image, but equally, deliberately juxtaposing your subject to a construction of a different era or style can be a very effective way of drawing attention to the characteristics of each building. Our conscious minds tend to ignore what we do not consider important and so we filter out the crane or the modern office block when we are 'on the street'. But photography can point out what will be routinely ignored by the casual observer, and in the expressive monotone of black and white, the form, structure and decoration of architecture can be captured in a way no other medium achieves.

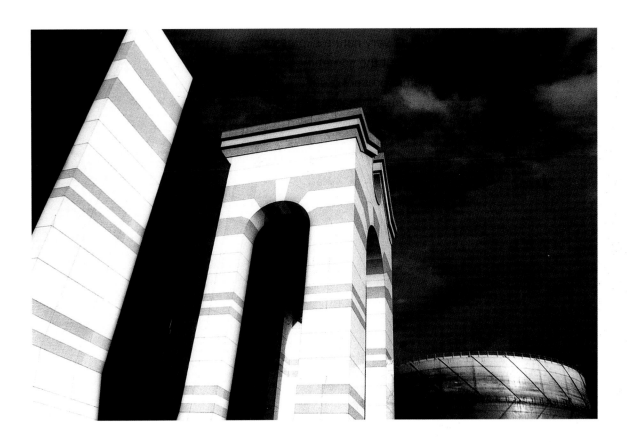

New building and gasometer

On a stormy winter's afternoon in London, with low cloud racing overhead and the sunset looming, there had been few opportunities for photographs. Just as I was leaving Battersea Park though, the sun broke through and illuminated this building and the gasometer beyond. The light on the side of the building was strong and the sky dark, so a careful reading of the light was needed. I took an average meter reading of the scene and, knowing that the newer building was the lightest tone, opened up one stop, to allow it to register white. The juxtaposition of these two buildings highlights the architectural irony – the much older, modernist gasometer next to the eighties building in the foreground, which refers to Egyptian and classical architecture.

35mm SLR camera, 28mm lens, orange filter

80 See in two dimensions

The successful black-and-white photographer has eyes for how the colour, tone and shape of everyday things will translate into the play of tone and light of a monotone image. However hard you try to faithfully represent what you see before you, it will always be transformed into a new form by the removal of colour. Far from being a drawback, this is the essence of the art: to be able to see a subject and not think about taking a picture of it, but rather of how you can create a photograph from it, is one of its chief pleasures. Architectural forms by their very nature express shapes in three dimensions, but the sometimes complex structures of architecture present great opportunities to create two-dimensional designs and patterns in a black-and-white photograph.

Roof structure

I liked the fact that this conical roof shape looks like a flat lattice pattern. The photograph reminds me of a spider's web and only on closer inspection does the solid wooden structure appear. The weak sunlight was casting shadow but was not too intense. I took two average meter readings, firstly from an unobstructed patch of sky and then from the beams themselves, giving me the extremes of light and dark.

35mm SLR camera, 28mm lens, yellow filter

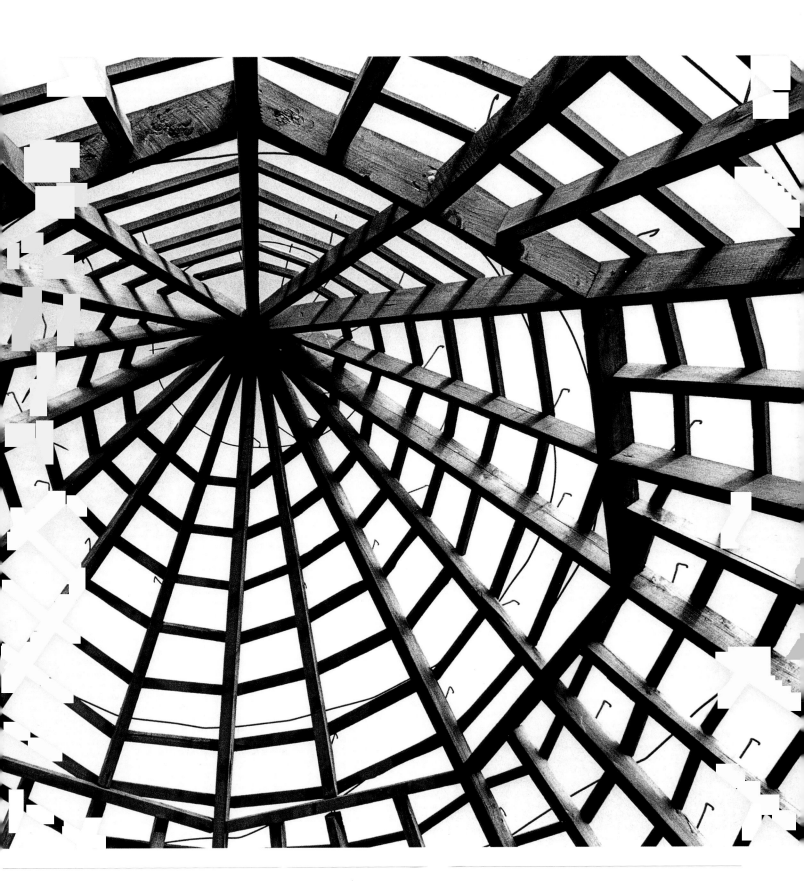

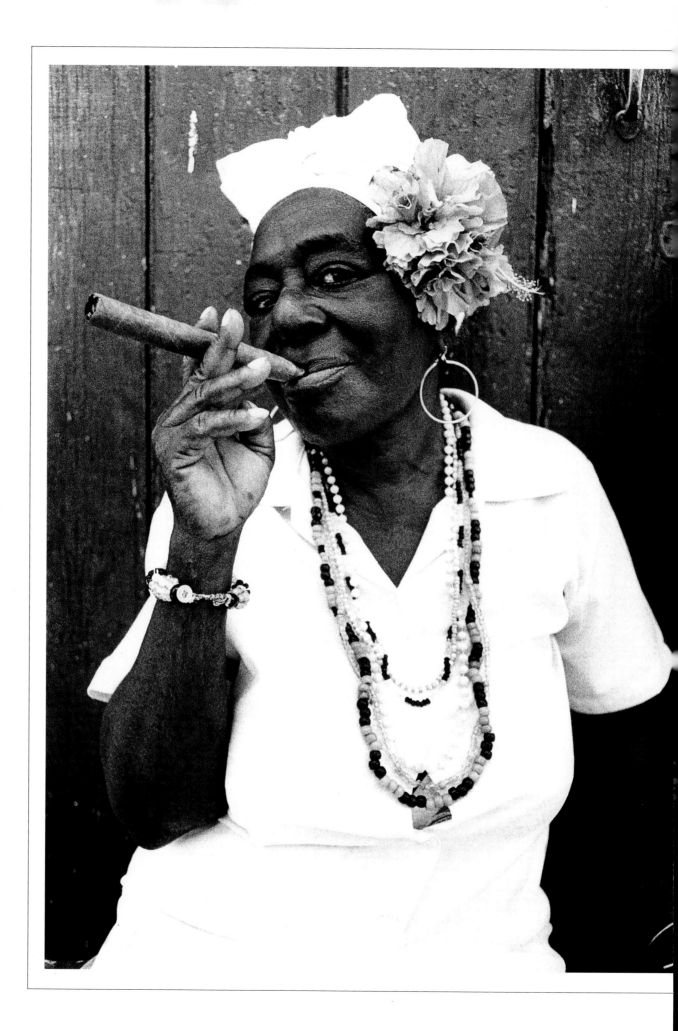

People

81 Use a telephoto lens for head shots

A long-focus lens can get you in tight when making a portrait, and a head shot that fills the frame can make for a very striking image. Trying to get this sort of frame-filling shot with shorter lenses can also make for interesting portraits but perspective will be noticeably distorted. A long telephoto will allow you to get in tight from a comfortable distance, and gives a more flattering perspective: crop into the head, and get sharp focus on the eyes.

Robbie

This was a promotional shoot for the model and I wanted to keep the style of dress simple: a T-shirt and sweater for a clean line around the neck and to create solid blocks of tone which would not distract the eye. Overall I wanted to keep a straightforward look to the picture. First I started shooting a formal head-and-shoulders portrait but as the session developed I realized that tighter framing was giving me a stronger image. The background was a plain wall in shadow and I used a silver reflector below the head to bounce even light up across the face which was also in the shadow of the wall. The reflector also gave a catchlight to the eye which I focused on and I set the aperture wide open, restricting the depth of field to the plane of the face.

35mm SLR camera, 200mm lens, yellow filter

117

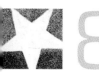

82 Photograph a group

Whether you are on the street shooting reportage or are just in the garden with the family, there are a few things you should take into account when shooting a group of people. First look at the overall shape of the group and move people to where you want them in the composition, and of course make sure everyone's face is properly visible. If you are on the street you will, often as not, have no control over the situation, so move yourself if you cannot move the group. Watch your background, making sure there are no distractions and that it will complement the subject; if not, change position or move the group to a more suitable background. Use a wide-angle or standard lens for a larger number of people; for two or three people a long-focus lens will be more suitable. Concentrate on how the group is moving and wait for the moment when everybody is as you want them.

Youths

I asked these boys in the back streets of Havana, Cuba, if I could take their photograph and they arranged themselves loosely into a group. Inevitably they spread themselves too widely and the background was also cluttered and confusing. I found a better location using a doorway for a frame and re-arranged them into a tighter group positioning them according to height. I asked them to relax and look slightly above the lens, and taking an average meter reading, I shot four frames at the same exposure in quick succession.

35mm SLR camera, 28mm lens, orange filter

83 Make portraits in natural light

Natural light will often give the most natural look to a portrait, but understanding its vagaries can be a challenge. As with most forms of photography, it's not a good idea to photograph around midday when the sun is high as the light will be harsh and will give you deep shadows in the eyes and a long nose shadow. You can place your subject in the shade where the light will be softer and more even, but it may be too flat for black-and-white photography which always works better with good contrast. Direct sunlight in the early morning or late afternoon will give the best results, but you should keep a close eye on awkward shadows (particularly from the nose) and make sure that the light is not in your model's eyes or causing them to squint.

Andy

This portrait was taken at a sports-ground in early autumn sunshine. The atmosphere was crisp and clear and the late afternoon light was good for modelling. I wanted to shoot in the direct light and used the shadows falling on Andy from the grid pattern of the fence as a feature. The wind was blowing fairly stongly so to complete the natural feel I threw some leaves against the fence and they were held there by the wind. I used a long lens for a flattering perspective and got Andy to walk towards the camera to create the casual animated pose.

35mm SLR camera, 200mm lens, green filter

84 Use tungsten light

A great advantage of using tungsten lighting in a studio situation, rather than flash, is that you see exactly what you are getting. You can see what is lit and what is not and meter the light accordingly, and with black-and-white photography there are none of the worries about correcting colour casts. A simple headshot, for example, can be lit by two anglepoise lamps. For half- and full-length subjects you will need a larger lamp or two, at around 800 watts each. Use tracing paper as a diffuser with the larger lamps to soften the light and the intensity of shadows. Flags and masks on the lights can control areas of shadow and form shapes at will. Be aware of the heat generated by the lights though, and don't place them too close to your model.

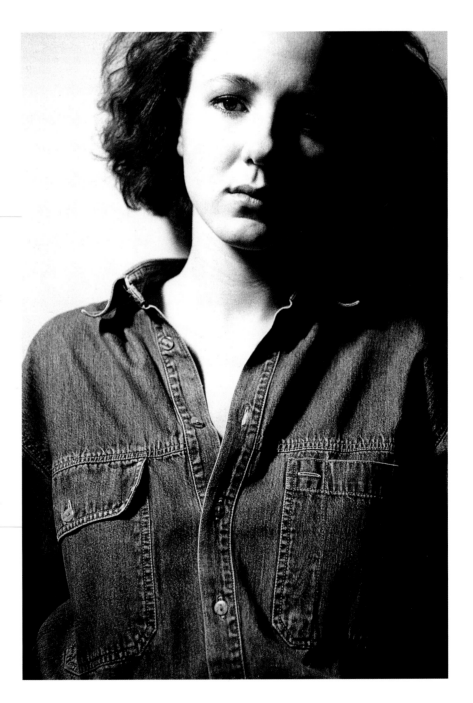

Siân

This was a simple portrait and I was concentrating on the mood and atmosphere of the lighting. I used a medium telephoto which flatters facial features and a single 800-watt tungsten lamp, and placed it on a stand to the left of the model. Diffusing the strength of the light source with tracing paper allowed me to soften the shadows and control the highlight area. Making small adjustments to the lamp, I took meter readings from the skin and used a wide aperture, keeping limited depth of field focused just on the plane of the face.

35mm SLR, 105mm lens, yellow filter

85 Pose your model with care

When taking portraits, particularly formal or studio portraits, it's easy for apparently insignificant details of a model's pose to become picture-ruining problems in the final print. What seems like a perfectly natural crossed leg, or hands one placed on top of another, can look unnatural and even bizarre when subjected to the scrutiny of the camera. The position of head and hands is extremely important: the head should not be tilted to extremes, and hands must look relaxed and neither clenched nor rigid. Hands should either be clearly in view or not in the picture at all, and it's a good idea to try to keep a slight curl to the fingers. Watch out for every nuance before committing to a shot, and it will certainly pay off in the quality of your portraits.

Michelle

Trying to recreate an old Hollywood-style image I used two 800-watt tungsten lamps and uprated the 400 ISO film to 1600 ISO; I also placed part of a stretched black stocking over the lens, secured by a rubber band, to exaggerate the grainy effect of the film. Placing the model into this striking pose, I had a make-up artist on hand to carefully arrange the hair. The model was very natural in her movement so I did not have to worry too much about tense hands; instead I paid close attention to the position of head, hands, arms and legs in order to retain compositional balance but keep the unusual pose feeling entirely natural.

35mm SLR camera, 105mm lens, green filter

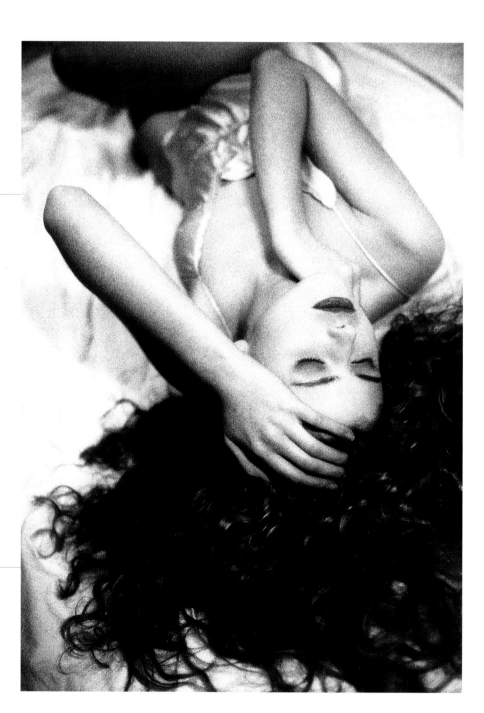

86 Shoot from above the model's eye level

Shooting from slightly above your model's eye level will usually produce a more attractive and flattering result than if your viewpoint is at the same level or slightly below. The model's face will appear more defined and angular, and if getting them to sit down makes them more relaxed, all the better. Ask the model to look slightly above the camera and not straight into the lens. Be aware of the psychological effects of your model looking up at the camera (or down for that matter). A model's head position can have a powerful effect on how they come across, and looking up at the camera has a tendency to make them appear subordinate or diminished in status.

Jasmin

I set up a small studio for this portfolio head shot, using a black background and one 800-watt tungsten lamp. I was aiming at a stylish, simple and direct image. I stood on two phone directories to get me to the viewpoint I was after, and the camera was mounted on a tripod. The lamp was slightly to my left and diffused, and I placed a black board by the model's side, to create a shadow line in her cheek. A silver reflector in front of her ensured the lighting was even. Using a telephoto lens helped to shorten the nose and chin and present as flattering a portrait as possible.

35mm SLR camera, 200mm lens, yellow filter

87 Get down low

Just as shooting from slightly above can be good for a head shot, a low viewpoint is often the best choice for half- and full-length portraits. It can be surprising how a change of perspective can alter the image. Just as looking up to the camera can make the sitter look subordinate, shooting up at them will make them seem taller, more powerful and, depending on the expression, even haughty or arrogant. For half- and full-length portraits use a long-focus lens; anything above 105mm and even up to 500mm is used for fashion work. It's possible to use a tripod kneeling down, but if you need to lie down to get the angle you want you will have to hand-hold, so use a fast shutter speed to avoid camera shake.

Amanda

Working on a series of photographs of workplaces as a fashion project, I set up a shoot in a garage and arranged for the use of the classic Chevrolet car. I lit the scene using two 800-watt tungsten lamps mixed with daylight and at first shot a series of half-length portraits. Changing to full length, I took this shot from a kneeling position using a monopod to steady the camera. I only wanted the model and the front of the car in sharp focus so I used a wide aperture and set the shutter speed at 1/250 sec.

35mm SLR camera, 200mm lens, yellow filter

88 Photograph different generations together

As a rule people tend to stick with their own generation and so very often in group photographs you do not find old and young together. Family groups are the obvious exception to this, but putting people together of different generations can have a powerful psychological as well as visual effect on a photograph. The old have character, wisdom and experience; the young, vibrancy and energy. Bringing them together can give you a clash of cultures, and tension in a photograph. Or if portrayed sympathetically they can represent a universality and feeling of passing down knowledge. Sometimes the photograph is less about the individuals and more about them acting as symbols for their own era.

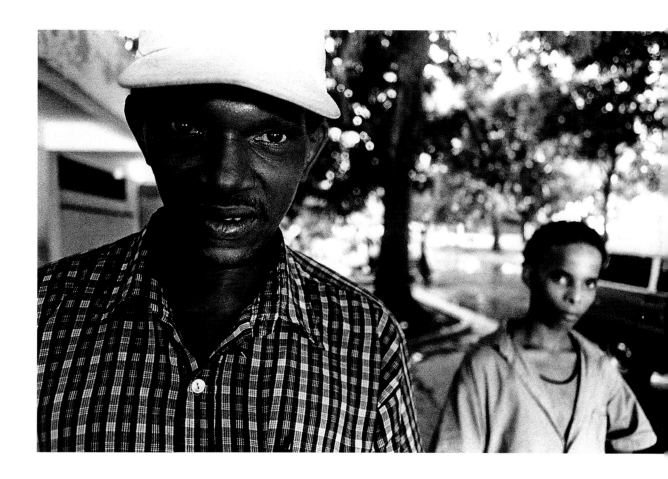

Man and boy

Near the end of a day's shooting in Havana, Cuba, I came across a local guy who wanted to make conversation. After speaking for a few minutes I asked if I could take his picture, and as I started to compose, a young boy walked into the frame. The boy knew the man and I asked him if he would be in the photograph as well. Recomposing I placed the boy to the bottom right of the image, and as he was not the dominant figure, opened the aperture to throw him slightly out of focus. The man remains the main character and structure to the image but I think the boy makes the picture: he is in the man's shadow, like the future waiting in the wings for its time to come, or an echo of the man's own youth.

35mm SLR camera, 28mm lens, orange filter

125

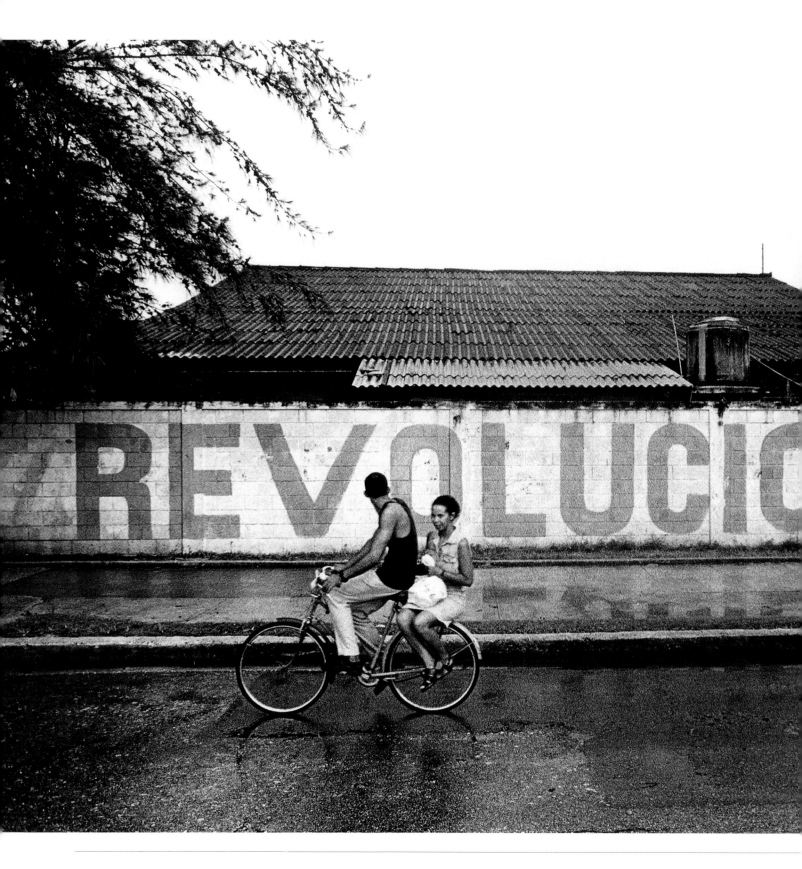

89 Anticipate the situation for reportage shots

The photojournalistic or reportage style, capturing people unguarded and unposed in real life situations, is perhaps the most powerful way of portraying people. Black-and-white is the natural medium for reportage, as exemplified by the great masters of the genre such as Henri Cartier-Bresson. Of course the drawback is that you don't have control of your subject in the way that you do with formal portraiture, so try to anticipate the situation. Research what is likely to happen, how people are likely to move and where they will go. Visualize how you would like a shot to work, and let people move into the space you want them in. If you use the manual program on your camera, pre-focus, read the light and set the aperture and speed; compose the image and wait. Then allow the subject to move through the space until they are where you want them, and shoot.

Street slogan

The streets were still wet after a short tropical rainstorm in Cuba when I came across this painted slogan on a wall and thought it would make a great backdrop for photographing local passers-by. Taking a spot-meter reading from the road and wall I set the camera, positioned myself and waited. After a few old American cars (typical of Cuba) had passed through the frame I saw the bike and riders approaching and realized that this was my shot. I waited till just after they had passed through the vertical centre of the image and shot just one frame.

35mm SLR camera, 28mm lens, orange filter

90 Look for unusual views

There are many ways of taking portraits, from traditional formal set-ups to snatched moments taken with the subject unaware of the photographer. The looser reportage style is certainly more popular these days, but it doesn't mean that you have to sneak around taking pictures of people unawares. With a bit of thought it is possible to set up unusual and informal compositions which capture your subject apparently unposed but are nevertheless carefully constructed and powerful images. Look for unusual views, use the graphic shapes of doorways, windows and stairways, photograph your subject reflected in windows, mirrors or water; this approach will give you an interesting and original portrait.

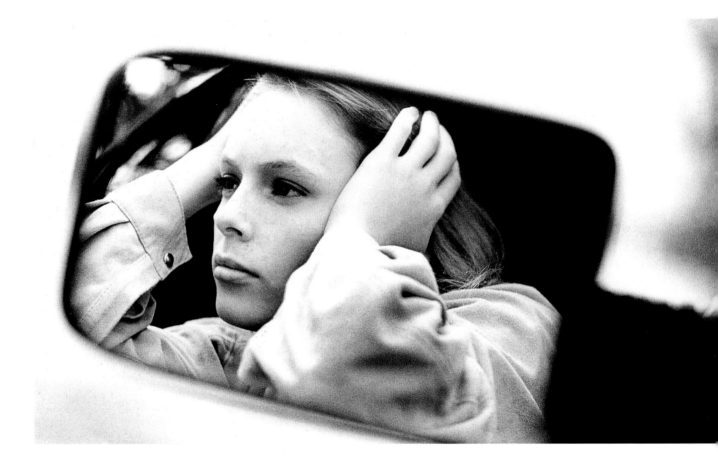

Girl in a car mirror

I had planned to take a photograph of someone looking out from the window of a car including their reflection also visible in the wing mirror. When it came to it I abandoned the direct view of the model altogether and instead concentrated entirely on the reflection in the mirror, which made a much more interesting and original composition. I took an average meter reading and set a wide aperture as I was only focusing on the flat plane of the mirror itself and everything else could be thrown out of focus.

35mm SLR camera, 200mm lens, green filter

91 Make use of props

Props can be very important in giving meaning to portraits either by making sure your subject is surrounded by things that relate to their work or interests, so that something of their life and personality is reflected in the picture, or on a simpler level using a prop as a graphic tool for composition. In a formal portrait you might want to strategically place certain items in the frame such as books or ornaments that give a clue as to your subject's life and personality; alternatively, from a purely visual point of view, a prop can provide opportunities to create interesting compositions – introducing a strong shape or line such as a car or a musical instrument will give life and movement to a composition.

Girl on rock

This photograph was taken on an area of beach in southern England that had been used during the war for army training and there was still some debris left over from the concrete fortifications. I used a piece of old cable as a way of framing my model, which simultaneously serves to enhance the strength of the composition and gives the model a feeling of health and vitality – the rope makes one think of skipping, but also in supporting it she holds her arms aloft as if in jubilation at winning a race. I shot using a wide-angle lens to help elongate the body.

35mm SLR camera, 28mm lens, green filter

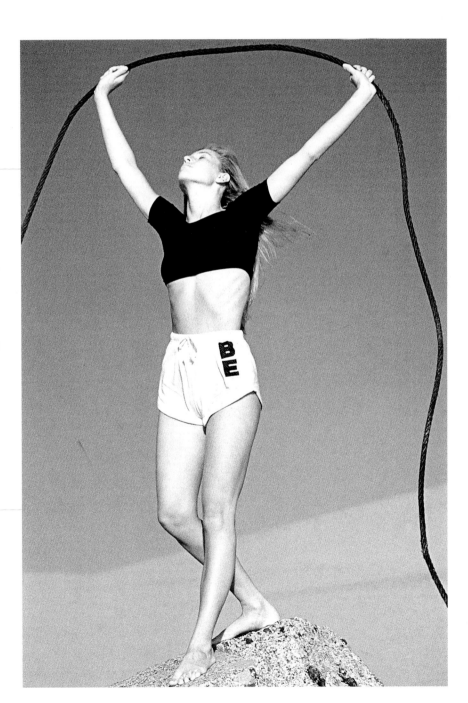

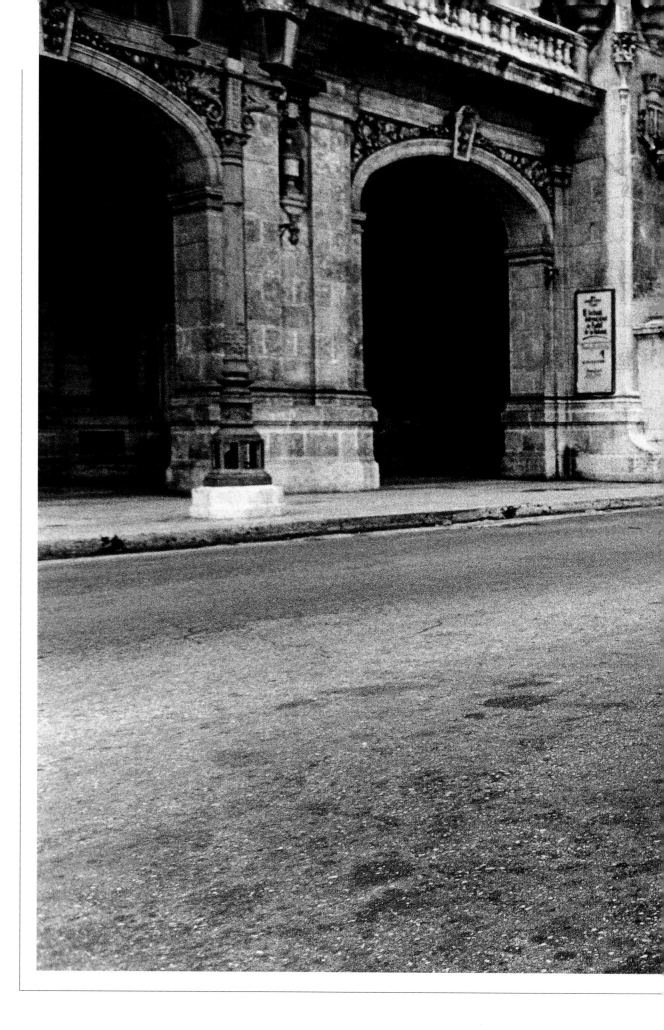

Travel

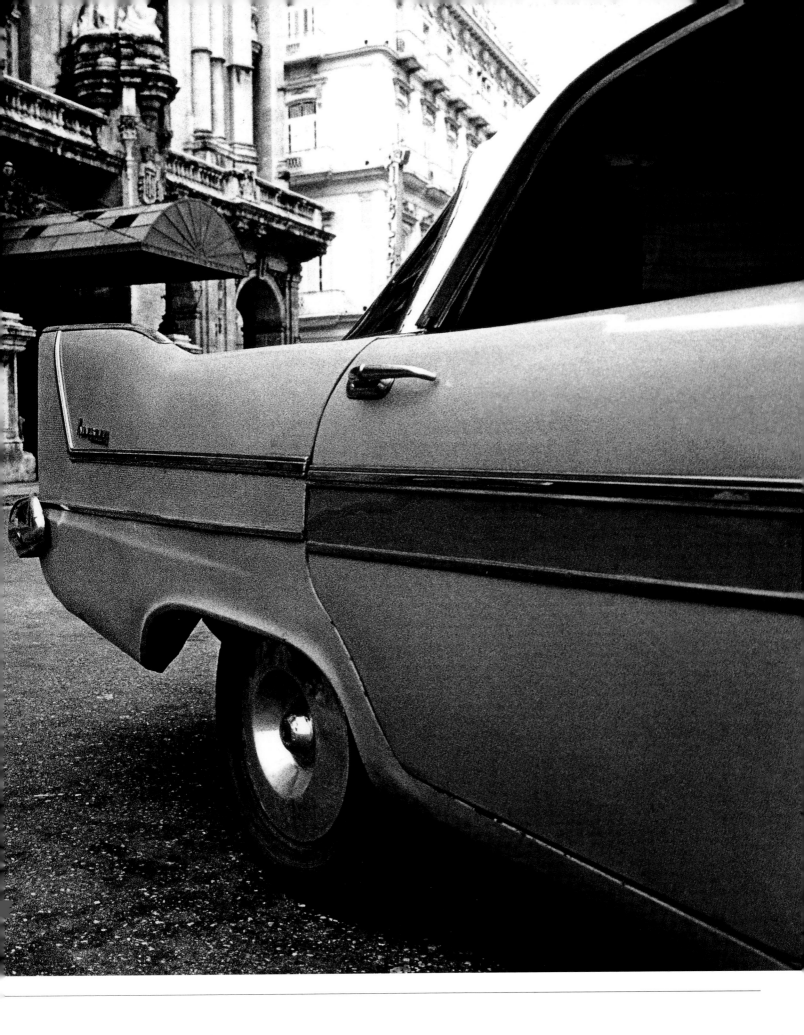

92 Explore places of local interest

Wherever you are, there are always plenty of good photographic opportunities if you are prepared to do a little research or give it a little thought. You may visit a city knowing half-a-dozen famous tourist destinations that have been regularly photographed (which you may intend to photograph yourself or avoid) but a visit to the Tourist Information Centre or simply looking at racks of local postcards will invariably reveal dozens of lesser known locations. There may be local festivals and cultural events, small museums, historic buildings or ruins, ancient sites or battlefields which will keep you busy whether or not you want to add your version of the Eiffel Tower, Sydney Opera House or Golden Gate Bridge to the many that have come before.

Rusting tank

The battlefield site of Dukla in former Czechoslovakia is not well known in the West because, although the battle fought there was one of the largest of World War II and many thousands lost their lives, the combatants were Russian, German and Czechoslovak. The site is now a museum of sorts with tanks, field guns and other military hardware scattered across a wide area, left in the fields where they fell; and here I came across this Russian T34 tank. Using the tank's turret to lead the eye through the picture, I took an average meter reading of the whole scene in order to set my exposure.

35mm SLR camera, 28mm lens, orange filter

93 Look for local detail

Famous buildings and landmarks identify a location in a very straightforward manner, but it is also possible to show local identity by searching out small details. Advertisement hoardings, shop signs, displays in market places, local crops and products, architectural details, modes of transport and regional dress can all identify a place and its culture in a subtle and understated way. Building up a series of such images can be a great photographic project and an even more effective way of showing the character and atmosphere of a location.

Bookstall

This photograph may not immediately identify the location as Havana, Cuba, but I found the arrangement of the stall and the books on sale fascinating, and once you know that it is Cuba, how could it be anywhere else? The books were under a canopy and in even light, and so I took an average meter reading, opening up one halfstop to lighten the whites. I also tried two other similar compositions for a choice of viewpoints.

35mm SLR camera, 28mm lens, yellow filter

94 Photograph industry

The industry of a location defines its character to a great extent. It doesn't necessarily mean factories of course; local industry might be farming, or fishing. The dominant local industry is a great place to start looking for images that capture the character of a place, as activity and people will inevitably revolve around it. Getting access to photograph heavy industry is often not possible, so you may have to search around for a good vantage point. Places like docks may have easier access, but don't just rush in and start shooting: be sure your presence is noticed and show your camera so you don't look suspicious. You need to read each situation separately, but often it's a good idea to play safe and ask someone's permission to take photographs.

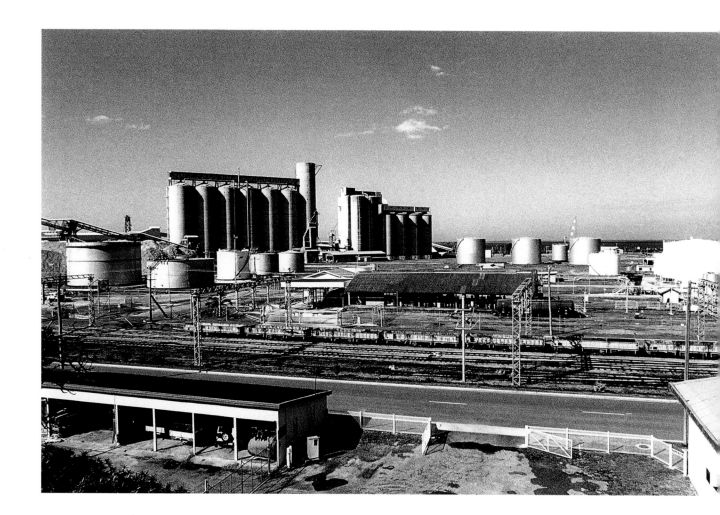

Aluminium factory

Queensland, Australia, occupies an enormous area of land and its industry operates on an equally massive scale. Visiting the town of Gladstone, I discovered that it was defined by the production of aluminium, the area being the largest producer in the southern hemisphere. It wasn't possible to photograph inside the plants but by choosing a high vantage point on the perimeter of this factory and using a wide-angle lens I was able to capture something of the scale of the place.

35mm SLR, 28mm lens, green filter

95 Photograph sculpture

Sculpture is a very powerful subject for black-and-white photography, the emphasis being on shape and form rather than colour and movement. The particular talent of the monotone medium to express shape, tone and texture lends itself particularly well. There are suitable subjects everywhere, from famous statuary such as Michelangelo's *David* to a fountain in a village square or hundreds of saints, animals and gargoyles on a church. Twentieth-century abstract sculptures by artists such as Henry Moore or Barbara Hepworth can make particularly successful subjects for a study in black-and-white. I usually use a wide-angle lens for this type of subject but if you want to isolate sculptures high up on churches or great buildings, you'll have to reach for the telephoto.

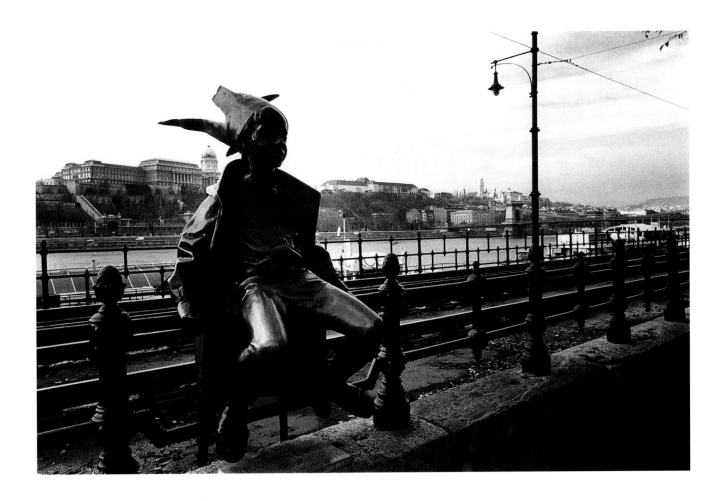

Elf

This intriguing bronze-work of a boy sitting on a fence is in the city of Budapest, Hungary. A tramline runs along the fence behind him and I used the parallel lines of the rails and fence to lead the eye from the statue into the picture, and so towards the city in the background. Focusing on the boy and using a small aperture, I metered on the background knowing that the statue would record in dark tones. I then made a series of exposures, bracketing half a stop either side.

35mm SLR, 28mm lens, green filter

96 Look down the backstreets

One tends to be drawn to famous landmarks, great buildings or grand vistas, but don't ignore the backstreets while travelling. Deserted and run down or bustling with life, there is often a wealth of interest here and a lot of detail to take in: narrow alleys, crumbling walls, people going about their business, shops and homes mixed together, washing hanging out, all types of transport, workshops and stalls on the street. A wide-angle or short telephoto lens is best suited for this work, and fast film will allow you to use a fast shutter speed so you can hand-hold, keep on the move and capture other things on the move.

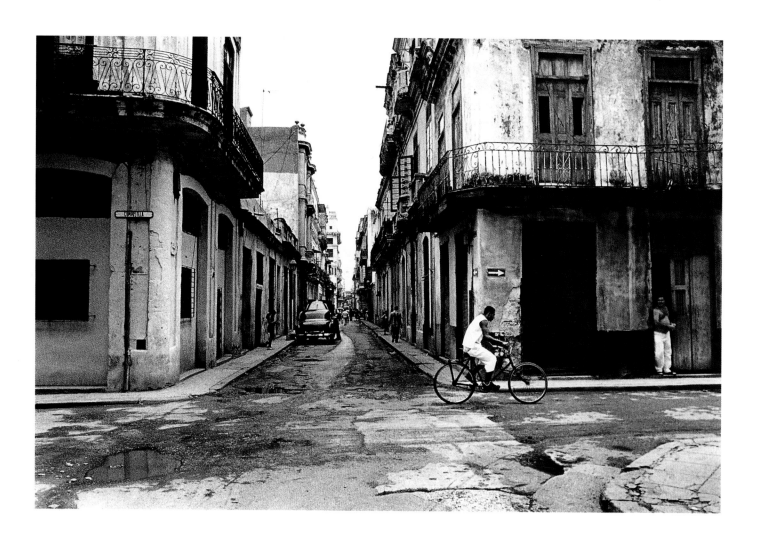

Street scene

The maze of backstreets in the old part of Havana, Cuba, are full of character and when I noticed this cyclist, I decided to make a feature of him against the backdrop of the empty streets. I therefore set up the composition and focused on the building and the street opposite, letting the cyclist ride into the spot in my frame that I thought best, and then I made a single exposure.

35mm SLR, 28mm lens, yellow filter

Don't ignore the gritty

Whatever your destination in the world, even in the smartest modern cities, you don't have to look far to find neglected areas of run-down buildings, graffiti-covered walls and general urban decay – in short, the rather more gritty side of life that the tourist office would rather you didn't see. For a photographer though, this can be a rich source of material, and the subject matter often suits the black-and-white medium perfectly. I tend to use a fast film for this type of shot to achieve higher contrast and accentuate the grain in the film.

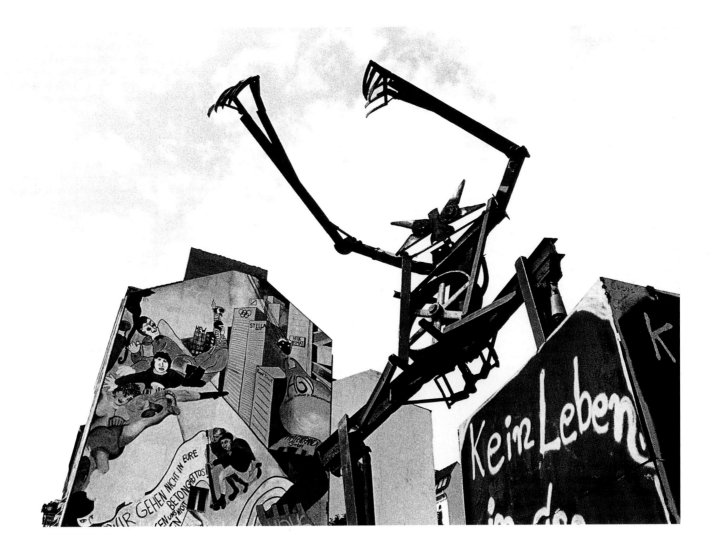

Metal man

I found this striking but rather dark and angular sculpture in a run-down area of Hamburg, Germany. There were large murals on the end of several buildings and a number of other metal structures and graffiti in all the paved areas. I took meter readings from the building and the sky to set my exposure, keeping both foreground and background in focus, and photographed the sculpture from below in order to make the metal man appear to tower over the urban environment.

35mm SLR, 28mm lens, yellow filter

98 Photograph local transport

Transport is a part of everybody's life, but the modes can be very different depending on where you are in the world. You've got to get around somehow when you're in foreign parts, so I would strongly advise you to use the local public transport, as this will help you get to know a place and its people much better than hiring a car or following organized tours. Trains, taxis, boats, bikes, rickshaws: there's plenty of variety, and not only are the vehicles (and their drivers) often interesting in themselves, but they put you in contact with so many other photographic opportunities, whether these be your fellow passengers, or the street scenes all around.

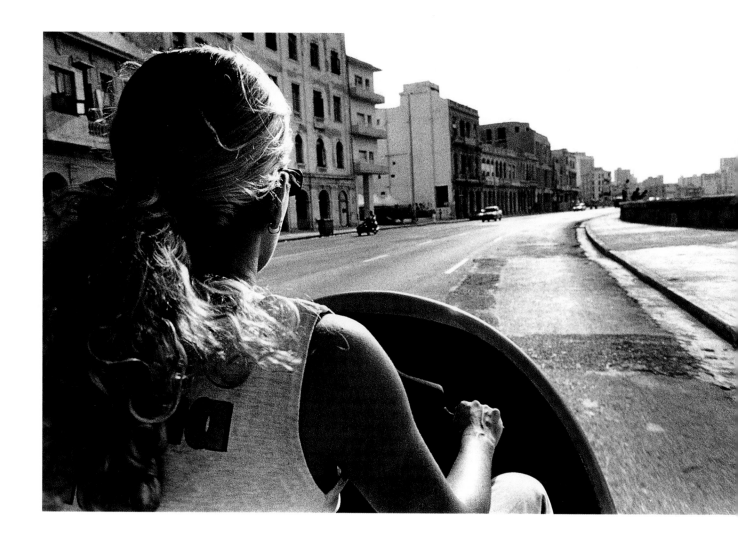

Scooter-taxi

Taking local scooter-taxis to visit different parts of Havana was a great way to get around. Speeding along the seafront one day to a marina a few miles further up the coast, I thought I could get some shots on the move. I set the camera, pre-focusing and taking an average meter reading, and then sat back and enjoyed the ride while waiting for a good picture to appear.

35mm SLR camera, 28mm lens, orange filter

99 Look for an unexpected angle

The famous views of a well-known building or landmark are very often the most readily accessible and therefore easiest to photograph, which is reason enough to look for an unexpected angle, and to try and create something original and unusual. Look for alternative viewpoints, use foreground interest or other structures in combination with your subject, exaggerate perspective, or manipulate the scale of your subject in relation to things around it by creative framing. Add further impact by manipulating the tonality through your choice of exposure: dark and brooding or pale and airy.

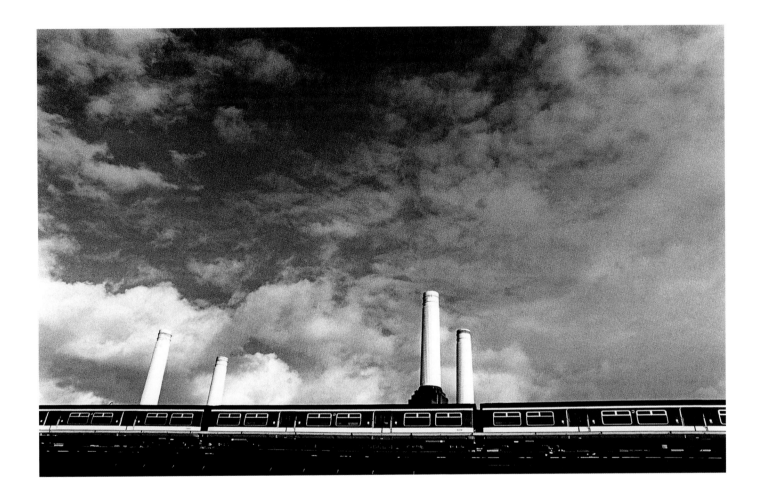

Power station

The four chimneys of Battersea Power Station are a familiar landmark to Londoners. It's also the largest brick building in western Europe, unfortunately now almost beyond restoration. Shooting close to the building one day, I was walking away but turned back for a last look and decided on one more image – and this was the result. I have photographed the building a number of times from various angles but my favourite image of it is this one. Photographs of it generally stress the massiveness of the brick structure and the enormous chimneys, but in this image the chimneys are dwarfed by the dramatic sky. and the main structure is almost entirely hidden by the railway carriages.

35mm SLR camera, 28mm lens, yellow filter

100 Photograph bridges

Travel

Most of the great cities of the world were founded on rivers, providing water and facilitating easy movement and trade. So in your travels you will inevitably find a great variety of bridges, from ancient stone crossings to fascinating ultra-modern designs. The infinite variety of bridges could make an interesting photographic project on its own, and the strong graphic lines intrinsic in the design of any bridge lend themselves particularly well to black-and-white work. Explore bridges from all angles, look from underneath them, walk across them, try a selection of lenses for different perspectives, or photograph the pedestrians and traffic using them.

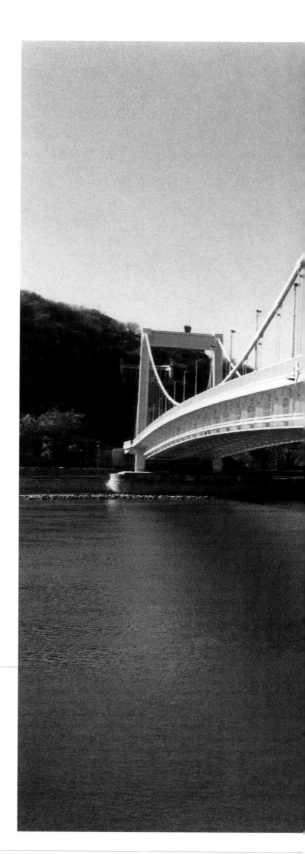

Bridge

When I first saw the River Danube I was very surprised to find that it *was* actually blue, due to the early morning sky reflecting in the water. I climbed on a wall and settled on this composition to create a clean white line right across the river which would lead the eye through the image. Taking light readings from the water, sky and bridge, I closed down half a stop from the average TTL reading to prevent the brightest areas of the bridge burning out completely.

35mm SLR, 28mm lens, yellow filter

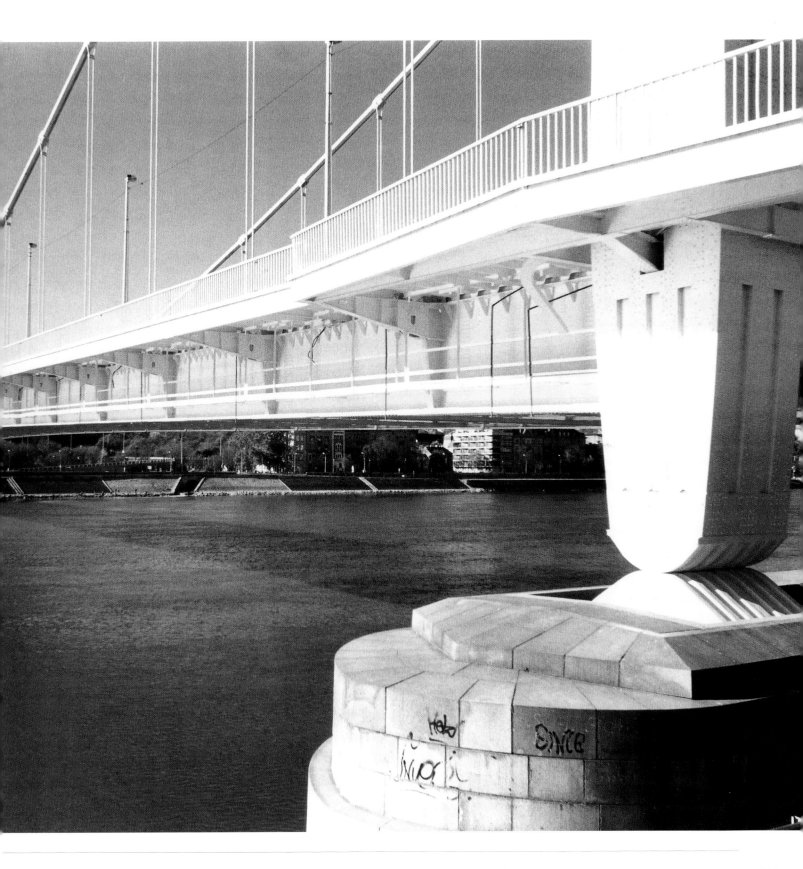

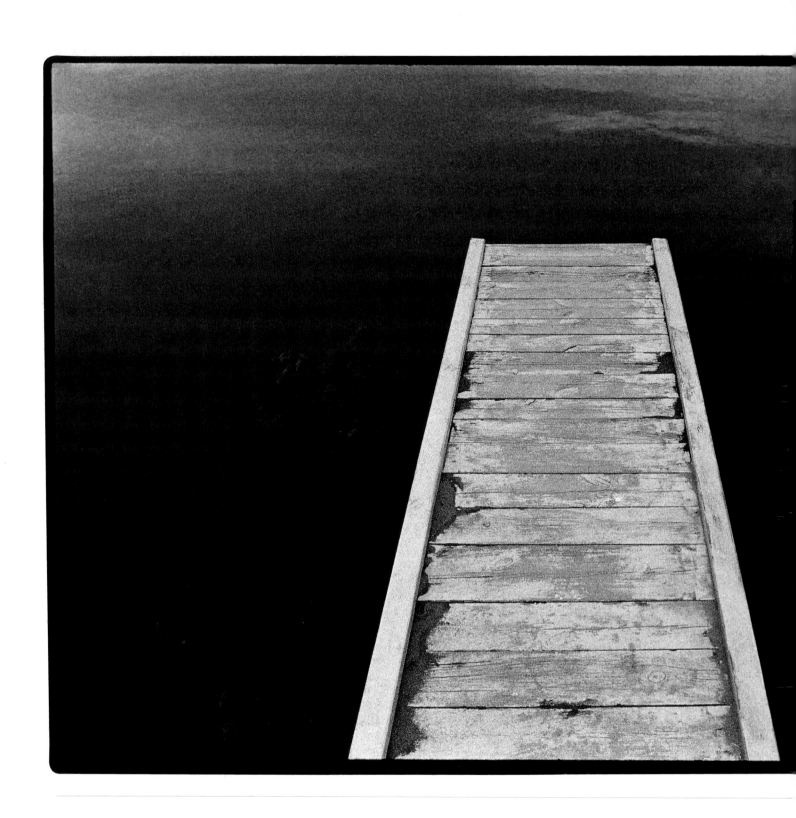

Acknowledgements

I would like to thank Julien Busselle,
Betsy Hosegood and Nick Albon for all their
help in the making of this book.

Jetty

Slovakia is a landlocked country but also a land of water,
known for its lakes and spas. On visiting a number of lakes
in mid-September, each place had an end-of-season feel to
it, the cafés closed and the boats tied up. This photograph
summed up the melancholia of this particular place, with a
sense of reflection and harmony. I took meter readings from
the jetty and water and set the camera so that the high-
lighted areas of wood did not record too bright and retained
maximum detail.

35mm SLR, 28mm lens, green filter

Index